IMAGES of America
MOUNT PLEASANT
1854–1954

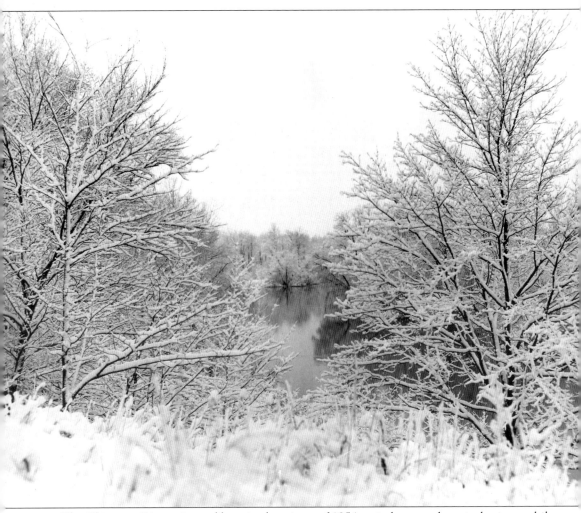

The Chippewa River, pictured here in the winter of 1954, quietly went about its business while the town of Mount Pleasant experienced a century of steady growth along its banks.

IMAGES of America
MOUNT PLEASANT
1854–1954

William Cron

Copyright © 2004 by William Cron.
ISBN 0-7385-3176-6

Published by Arcadia Publishing,
an imprint of Tempus Publishing, Inc.
Charleston SC, Chicago, Portsmouth NH,
San Francisco

Printed in Great Britain.

Library of Congress Catalog Card Number: 2003108122

For all general information contact Arcadia Publishing at:
Telephone 843-853-2070
Fax 843-853-0044
E-Mail sales@arcadiapublishing.com
For customer service and orders:
Toll-Free 1-888-313-2665

Visit us on the internet at http://www.arcadiapublishing.com

To Mindy, and to the people of Mount Pleasant, for always making life so interesting.

Contents

Acknowledgments 6

Introduction 7

1. Building a City 9

2. Hard at Work 29

3. Out on the Town 53

4. School Days 71

5. Higher Learning 85

Acknowledgments

Many thanks to Frank Boles, Jennifer Wood, and all of the archivists and librarians at the Clarke Historical Library, for their dedication to maintaining a world-class research facility without sacrificing personal attention. The great majority of photographs shown herein appear courtesy of the Clarke. Thanks also to Willie Jackson, Anita Herd, and the Ziibiwing Cultural Society for opening the ZCS archives and sharing photos.

INTRODUCTION

The years between 1854 and 1954 represent an incredible period of progress for what is now the city of Mount Pleasant, Michigan. What began as a collection of crude cabins, hewn from the forest through toil, determination, and not a small amount of controversy and deceit, had a century later become the commercial and cultural heart of mid-Michigan. As a 1954 pamphlet issued by the Chamber of Commerce claimed, Mount Pleasant "enjoys an abundant share of natural resources and prospers in a diversified economy. . . . It grows and progresses in well balanced interests of education, health, culture, industry, agriculture, recreation and religion." Most of the city's residents would agree that this statement is as true today as it was in 1954.

Although the scope of Mount Pleasant's progress during its first hundred years was exceptional, its story includes many elements typical of other Michigan cities during the same period. The land on which the city now stands was originally selected in 1855 to fulfill the stipulations of a treaty made between the United States and the Saginaw, Swan Creek, and Black River bands of Chippewa Indians. This land was then fraudulently acquired by timber prospectors, who made logging the first important industry of the region. The village of Mount Pleasant developed to service the needs of the men who logged the surrounding forests. As the forests disappeared, farms replaced them and the town continued to evolve to meet the changing needs of its citizens. In the later 19th century, industry came to Mount Pleasant in full force and bolstered an already thriving economy. Later, while other communities struggled in the wake of the Great Depression, Mount Pleasant prospered as a center for Michigan's oil and gas industry.

The benefits of this prosperity were tangible. Mount Pleasant became home to many fine houses, businesses, parks, churches, and public buildings. Railroad lines and a network of good roads serviced the town. Cultural opportunities abounded and the citizens of Mount Pleasant availed themselves of concerts, theatrical productions, sporting events, even opera. Fraternal and charitable organizations, among others, served to provide ample opportunity for social enrichment. An excellent school system developed and the town gave rise to a college that by 1954 had evolved into one of the state's foremost institutions of higher education. All of these things were signs of a community advancing steadily forward.

The photographs included in this book graphically depict many of the people, places, and events that made Mount Pleasant's initial century of progress possible. Beginning with its

first settlers, the people of Mount Pleasant built, worked, loved, worshiped, planned, struggled, dreamed, and ultimately succeeded. From 1854 to 1954, people with different backgrounds and different ideas came together in this place to give life to a truly progressive city. *Progress* is the theme that unifies the pictures in this book, and it is the one word that best characterizes the history of Mount Pleasant.

One
BUILDING A CITY

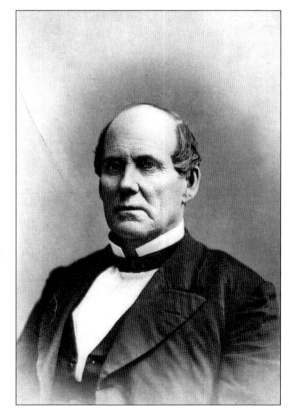

"Accompanied by a hired man, I proceeded high up the Chippewa River and found a few miles back, on the west side of the river, several small well-timbered tracts of fine cork pine, which I and other pine land lookers had failed to find in passing before too near the river. The localities of these tracts were good for early lumbering. On looking all up, I had twenty-one lots which fired my hopes, and added to my tranquillity [sic] of mind. . . . In fact, it dawned on my mind that I possibly might become wealthy, and leave my family free from the slavery of poverty."—Lumberman David Ward in his autobiography, upon first visiting the area that would become Mount Pleasant.

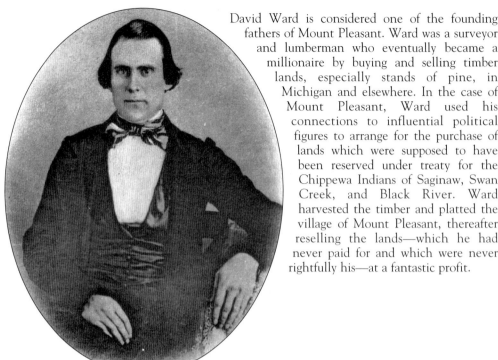

David Ward is considered one of the founding fathers of Mount Pleasant. Ward was a surveyor and lumberman who eventually became a millionaire by buying and selling timber lands, especially stands of pine, in Michigan and elsewhere. In the case of Mount Pleasant, Ward used his connections to influential political figures to arrange for the purchase of lands which were supposed to have been reserved under treaty for the Chippewa Indians of Saginaw, Swan Creek, and Black River. Ward harvested the timber and platted the village of Mount Pleasant, thereafter reselling the lands—which he had never paid for and which were never rightfully his—at a fantastic profit.

Although David Ward and his wife Elizabeth Perkins Ward, pictured here, never lived in Mount Pleasant for any considerable amount of time, he was instrumental in the establishment of the new village. After he had cleared the land along the Chippewa of its timber, Ward recognized the centrality of the site to nearby lumbering and agricultural activity. He bestowed the name of "Mount Pleasant" upon the place, a name which continues to puzzle visitors as its terrain is almost entirely flat. Having plenty of business elsewhere, Ward did not participate further in the growth of the town he had envisioned but instead sold the land in the summer of 1863 to Harvey and George Morton of New York.

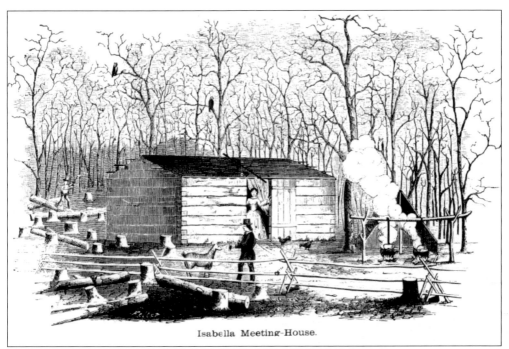

Isabella Meeting-House.

The first courthouse in Isabella County was located in a log building at a place known as Isabella Center. It served not only as a courthouse, but also as a hotel, a store, and a place of residence. Pictured above is an artist's conception of that early building.

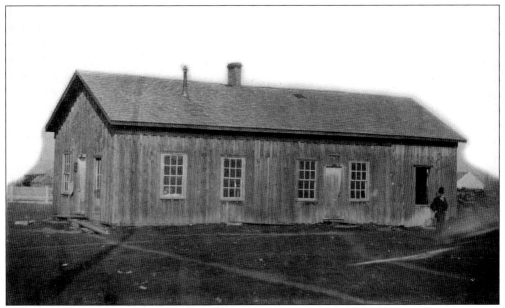

The first courthouse was short-lived as county residents voted in 1860 to move the county seat to Mount Pleasant. The small courthouse, pictured here, was built on part of five acres deeded to the city by lumberman David Ward, land which rightfully belonged to the Saginaw, Swan Creek, and Black River Indians. This simple structure proved to be inadequate to handle the needs of a growing community, but the village lacked funds to construct a larger building.

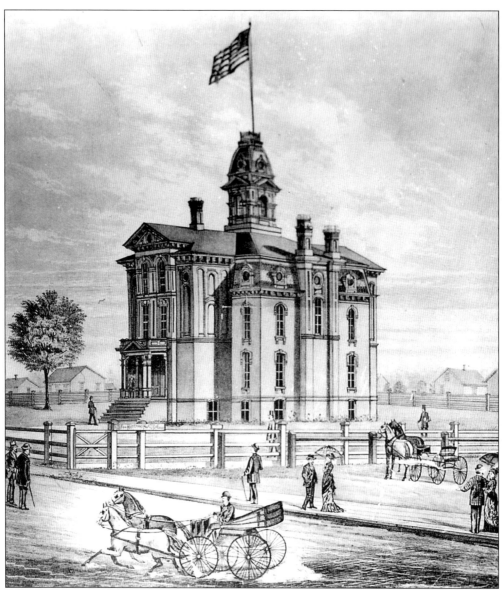

After finally obtaining funding for a new courthouse from the state, Mount Pleasant's small county building was demolished and replaced by the new courthouse, a much more accommodating structure, shown here. The new courthouse served as a point of pride for the community from its inception.

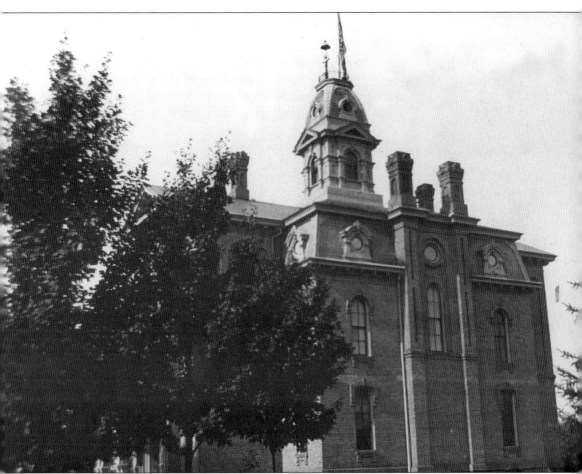

The beautiful new courthouse served the city for almost a century after its dedication on February 22, 1878. The dedication ceremony was accompanied by a great deal of pomp, including musical performances and speeches by civic leaders. When the building was ultimately demolished in the 1970s, its grand cupola was removed and it now rests outside the Isabella County Fairgrounds.

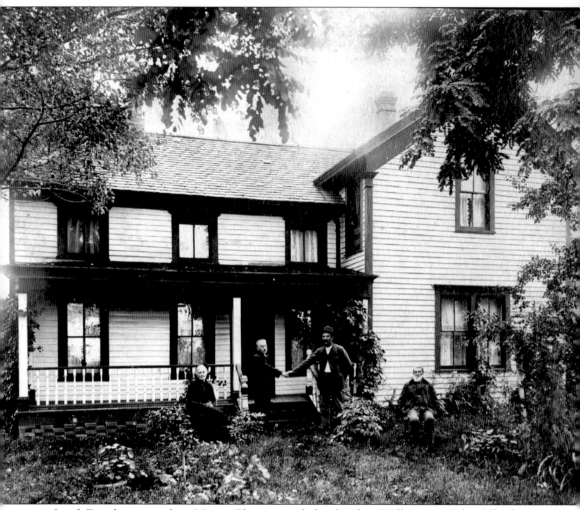

Jared Doughty arrived in Mount Pleasant with his brother Wilkinson in the fall of 1869. Doughty was an accomplished tinner, and seeing an opportunity in the small town of Mount Pleasant, he immediately opened a general hardware shop with his brother. In 1876, the brothers built a two-story brick block, afterwards known as the Doughty block, at the corner of Main and Broadway. In 1883 Jared erected another downtown building, this one a three-story structure farther east down Broadway, out of which he continued to operate a hardware business and tin shop. Pictured here is Jared Doughty's home on what is now University Ave.

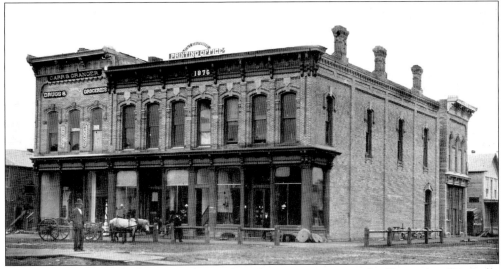

The most widely-read of Mount Pleasant's early newspapers was the *Enterprise*. Originally begun as the *Northern Pioneer* in 1864, the paper changed ownership several times and acquired its new name. As newspapers were highly politicized at the time, the *Enterprise*, like the town of Mount Pleasant, was solidly Republican. Shown here are the *Enterprise* offices sometime after 1875, when a disastrous fire consumed the paper's former offices. John R. Doughty owned the Enterprise from 1873 until 1885, when he sold the business to A.S. Coutant. Doughty was dedicated to the paper and when its offices burned in 1875, he issued the next week's paper from his home without missing a beat.

By 1888, the *Enterprise* had relocated to the smaller building pictured here. According to the inscription on the back of this photo, the people in the photo are, from left to right: "a butter in," C.W. Chase, Ora May Sanford, A.S. Coutant, M.L. Sherman, and "a passerby." Coutant was the owner of the newspaper at that time.

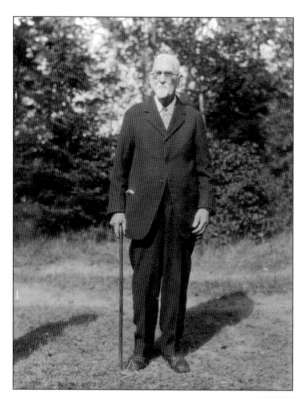

It is likely that no man has had a greater impact on the history of Mount Pleasant than Isaac Alger Fancher. A lawyer by trade, Fancher brought his family to Mount Pleasant in 1862 after unsuccessfully prospecting for silver in Nevada and California. From the start, he was a tireless promoter of his new home. In his first years, he surveyed and laid out hundreds of miles of roads throughout Isabella County and constructed a two-story store building at the corner of Main and Broadway.

Fancher was instrumental in bringing the railroad to town, raising funds to facilitate the installation of a line between Mount Pleasant and Coleman. He also headed up fundraising and planning efforts for many of the town's early churches. In 1867 and again in 1873, he was elected to the state House of Representatives, and in 1875 he served a term in the state Senate. Today a street in Mount Pleasant and a local elementary school bear the name Fancher, in tribute to the man who literally and figuratively put Mount Pleasant on the map.

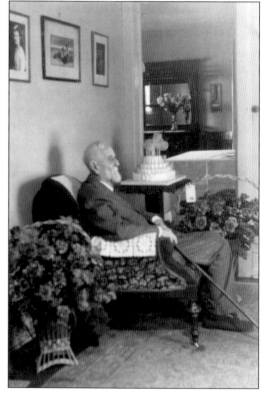

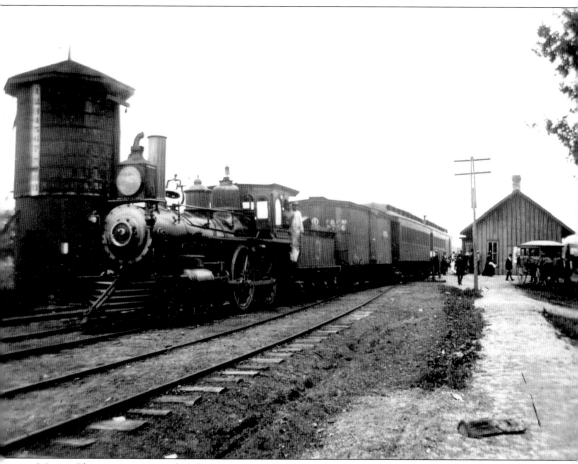

Mount Pleasant was an isolated city in its early days. The only transportation routes in and out of the city were the Chippewa River and a primitive road entering the town from the south. The Flint & Pere Marquette line ran across the northern edge of Isabella County as early as 1871, but this was of little use to the townspeople of Mount Pleasant, 15 miles to the south. Finally, on December 15, 1879, the town was connected by rail to the outside world as the Saginaw & Mount Pleasant line opened for business between Mount Pleasant and Coleman, where the line intersected with the Flint & Pere Marquette. Here is a train leaving from the first Pere Marquette depot near the corner of Bennett and Main. A new depot was built in 1904.

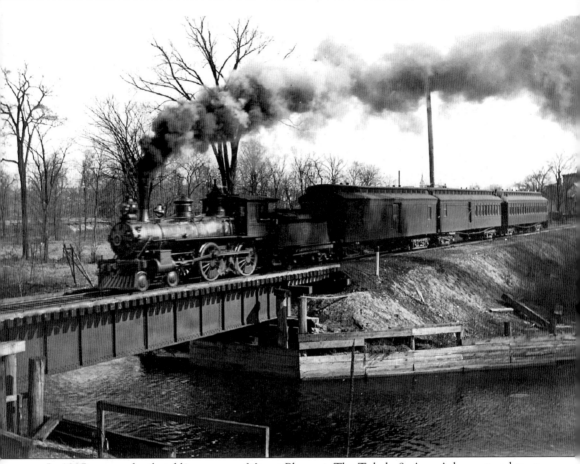

In 1885, a second railroad line came to Mount Pleasant. The Toledo & Ann Arbor entered town from the south, where it ran through Alma, St. Louis, Ithaca, and points beyond. The products of the farms and forests surrounding Mount Pleasant were now capable of reaching an outside market, and people were excited about the potential of the young city. Pictured here is Engine 8 of the Ann Arbor line with a passenger train in tow sometime around the turn of the last century.

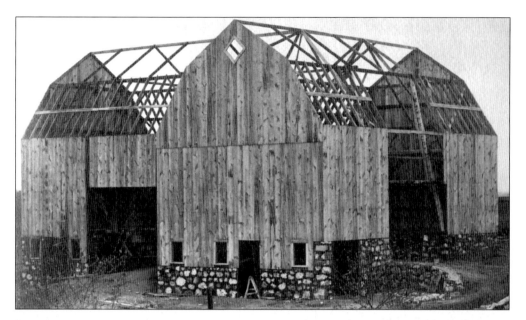

Barn-raisings were a common occurrence in Mount Pleasant during the population boom of the late nineteenth century. Shown above is a barn-raising carried out at 810 N. Kinney St. by carpenter Hugh Fox and his partner Isaac Clifford. Sometimes these events required the help of many neighbors, as in the unidentified early construction project pictured below. In some cases, for heavy, timber-framed barns or buildings, teams of oxen were employed to raise the walls of the structure. Horses were undesirable for this task because they were likely to pull the frame too quickly or too far forward.

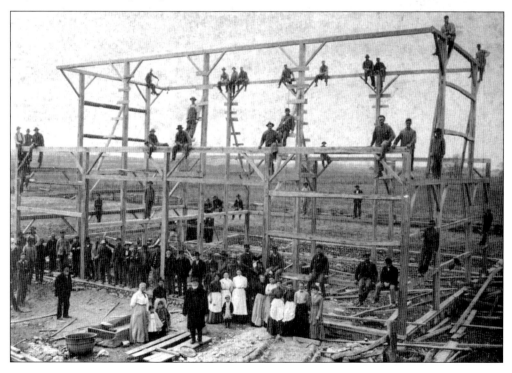

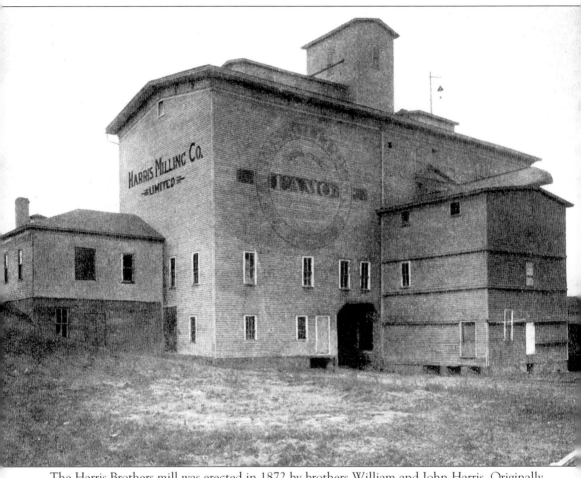

The Harris Brothers mill was erected in 1872 by brothers William and John Harris. Originally a much smaller structure, it expanded gradually and by the early 1900s boasted six water wheels. The wheels not only powered the company's operations, but provided excess power which the Harris brothers leased to such customers as the city of Mount Pleasant and the Mount Pleasant Electric Light Co. The mill was host to an extensive flouring operation, producing up to 150 barrels a day and marketing them under such brand names as "Famo."

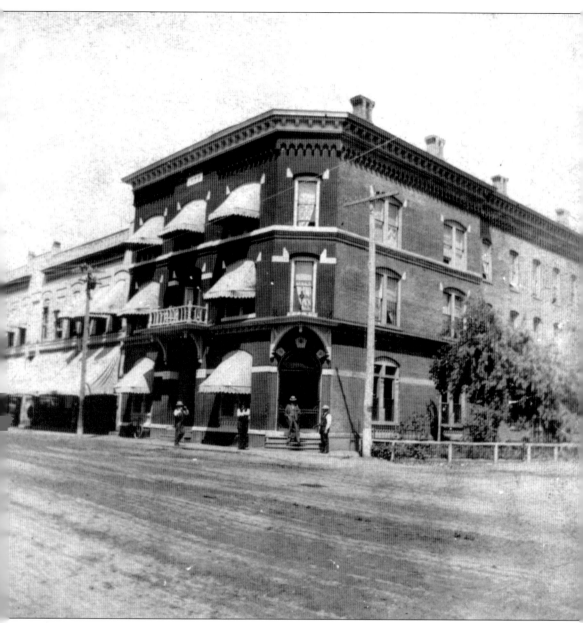

The most impressive of Mount Pleasant's early hotels was the Bennett House, pictured here. Cornelius Bennett, a wealthy local landowner, built the hotel in 1883 to accommodate the growing number of businessmen, lumbermen, and others who streamed into the town. According to a 1906 account, the hotel "contains fine bath rooms, and its bed-rooms are models of elegance, every room containing white iron or brass bedstands, the softest mattresses and the bedding of that snowy cleanliness that is a mark of good house keeping." Bennett was a popular local figure and was elected Mayor of Mount Pleasant for 1893.

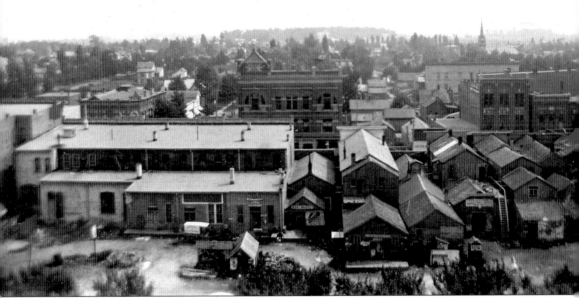

Beginning in the mid-1870s, Mount Pleasant experienced a surge of growth. The streets were busy, the hotels filled, and business was booming. The still-young town began to stretch from its limited beginnings off into the horizon, as shown in this later 19th century photograph taken from the courthouse tower looking southward.

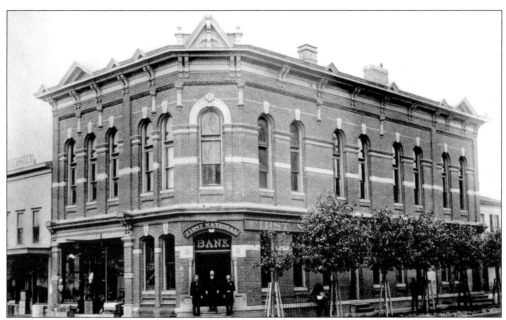

One of the earliest bank buildings in Mount Pleasant was constructed by Albert Upton at the corner of Broadway and what is now University Ave. The bank operated on the first floor while the Mount Pleasant Opera House carried on its business on the upper floor. When Upton retired in 1884, the bank became known as the First National Bank of Mount Pleasant. For a short period, the bank issued its own currency. Later it would become known as the Isabella County State Bank.

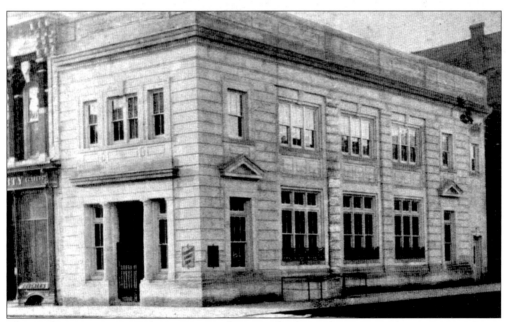

The Exchange Savings Bank was organized in March of 1894 by a group of enterprising Mount Pleasant businessmen. The building pictured here was located at the corner of Broadway and Main. It was the second building to house the bank, the first being a brick structure which quickly proved insufficient to handle the company's growing clientele.

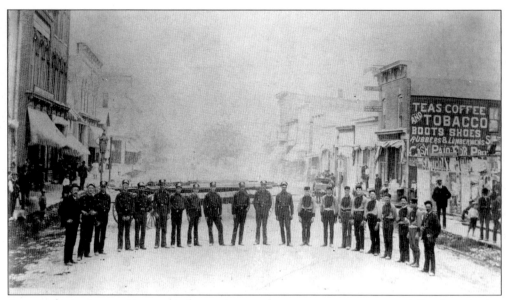

Among the most pressing needs of any nineteenth century town was a good fire department. This could not have proven more true than in Mount Pleasant, which was subject to two great fires in its early years, the first in 1875 and the next in 1882. The 1875 fire was particularly bad, destroying almost all of the buildings in the downtown area. After the fire, the *Enterprise* decried the town's lack of fire-fighting equipment, writing that "a few hundred feet of hose and a hand engine, would do a vast amount of good, and be in conjunction with the night watchmen a pretty effectual protection against fire. An engine house should be built, in which there should be a bell of sufficient tone to sound over the whole town."

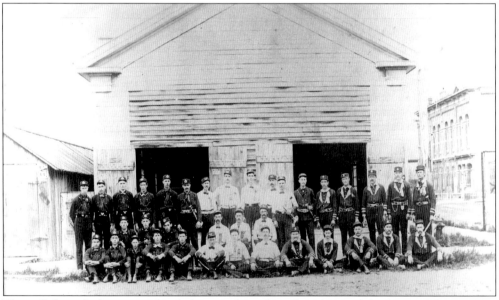

The call for a firehouse was heeded, as evidenced in this photo of the Mount Pleasant Fire Department and firehouse in 1887. This structure was located at the corner of Michigan and what is now known as University Ave. Henry Wilbur served dutifully as the bell ringer. At that time fire companies were comprised entirely of volunteers.

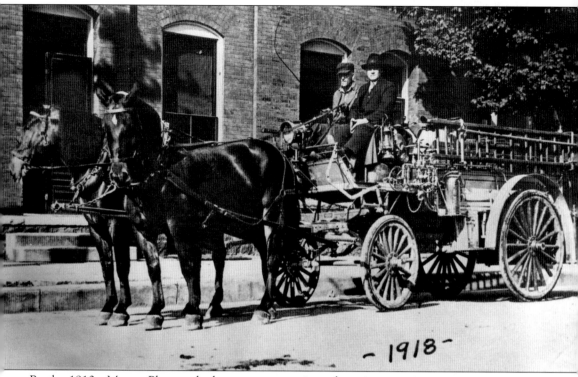

By the 1910s, Mount Pleasant had gotten more serious about its commitment to preventing major disasters. The engine pictured here, although drawn by a horse, was top-of-the-line equipment when it was purchased in 1913. In addition to putting out fires, the engine served many turns of duty as the leader of downtown parades.

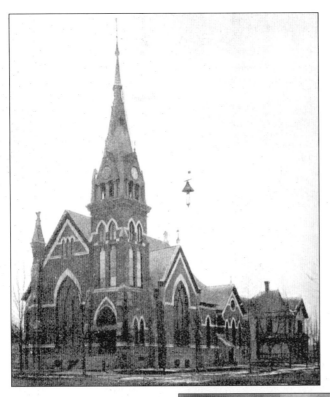

For the first decade after its founding, the population of Mount Pleasant was too small and counted too many seasonal logging workers to warrant an organized church. Residents met to worship together in each other's homes or in the schoolhouse, sometimes inviting itinerant preachers or missionaries to lead the services. Due to the efforts of several missionaries in 1864, a religious fervor gripped Mount Pleasant, and in 1865 the Methodists erected the town's first church. As the congregation grew, the new and bigger church, shown here, was erected in 1882 at the corner of Main and Wisconsin. The Methodist Episcopal church was one of Mount Pleasant's most important and beautiful buildings.

Sunday school was the norm for most young children in early Mount Pleasant. During the city's earliest years, there was only one Sunday school, the Union Sunday School, which was a multi-denominational Christian organization. The Methodist Episcopal Church attracted most of the Union students and teachers away to its own Sunday school, begun in 1868. This monopoly was later dissolved with the opening of more churches in Mount Pleasant. Sunday school classes, such as the group of young ladies pictured here, were at that time separate for boys and girls.

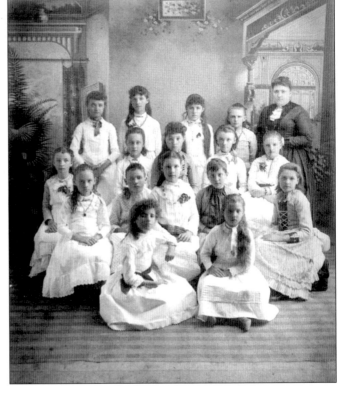

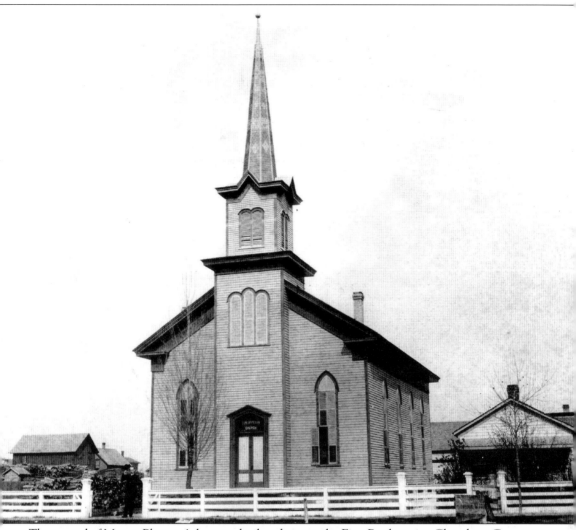

The second of Mount Pleasant's large early churches was the First Presbyterian Church on Court St. This structure was dedicated on January 31, 1875, with the dedicatory sermon delivered by the Reverend Thomas Middlemas of Saginaw. The event marked the largest religious gathering to date in Isabella County. The church was well-appointed, featuring new pews, a 12-light chandelier, and its most recognizable feature, a soaring silver spire atop the roof.

Mary Doughty, wife of Wilkinson, was instrumental in the success of the Presbyterian Society in Mount Pleasant. It was through her efforts that a Presbyterian-sponsored Sunday school was begun in 1869, attracting some worshippers away from the then-dominant Methodist Episcopal Church. Doughty worked with other women to raise funds for the construction of the First Presbyterian Church, often hosting socials at which guests were expected to make a contribution at the end of the evening.

The Presbyterian Church attracted many of Mount Pleasant's leading citizens, including Wilkinson Doughty, Samuel Hopkins, Charles Slater, and Isaac Fancher, pictured here with his son, Isaac Jr., in 1905. Fancher was one of the early officers of the Presbyterian Society, and in typical Fancher fashion, assumed a great deal of responsibility for promoting and raising funds for the construction of the church.

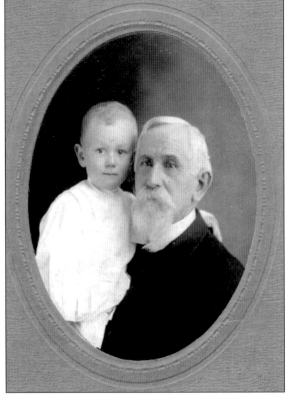

Two
HARD AT WORK

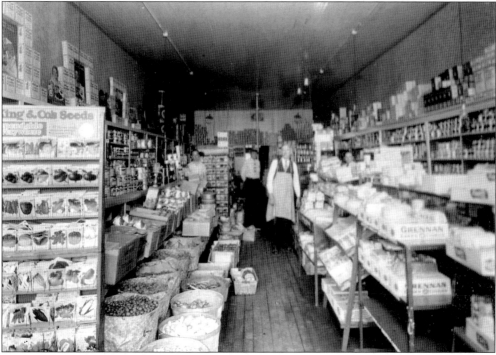

"It is easily explained why Mount Pleasant is considered one of the most prosperous and hustling of the smaller cities of Michigan. The business men of Mount Pleasant are of that class who keep everlastingly at it, and no sooner is one business enterprise secured than they are out and after another."—From *Faces and Places Familiar*, 1906.

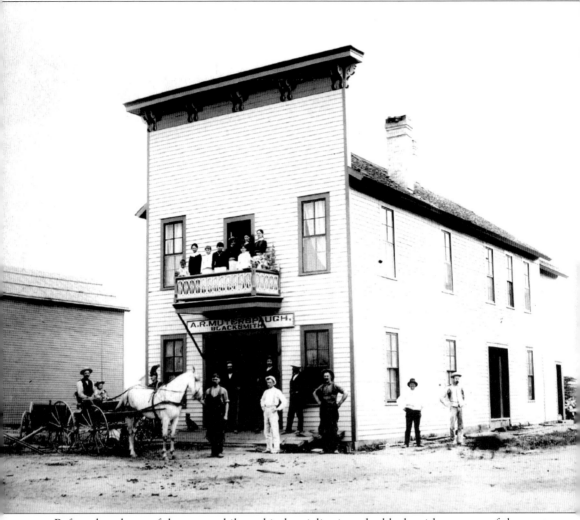

Before the advent of the automobile and industrialization, the blacksmith was one of the most important members of any community. In Mount Pleasant the smith was doubly important, due to the demand created by the presence of the lumber industry, with its many specialized tools. Shown here is the shop of successful Mount Pleasant blacksmith Andrew Muterspaugh.

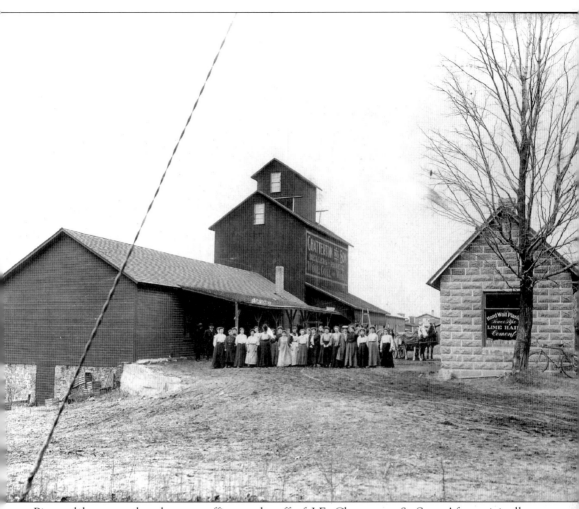

Pictured here are the elevator, office, and staff of J.E. Chatterton & Son. After originally operating a successful retail grocery business, the Chattertons purchased the Horning grain elevator in 1903 and entered the business of handling the products of area farmers. An especially important crop in the Mount Pleasant area was beans, which Chatterton & Son distributed both domestically and internationally.

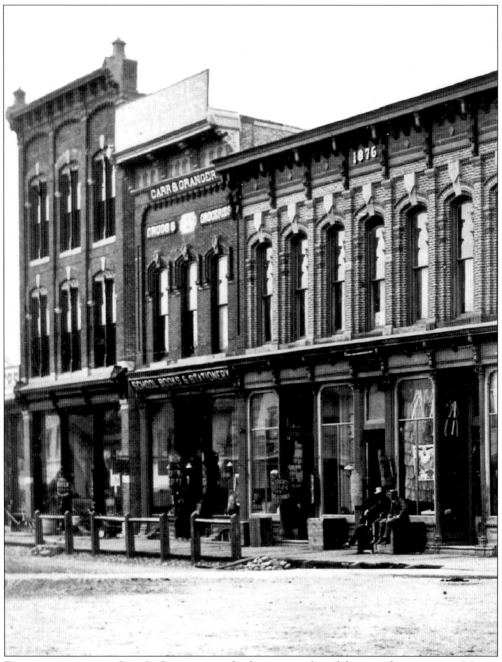

For quite some time, Carr & Granger was the largest retailer of drugs and groceries in Mount Pleasant. F.W. Carr and George Granger operated their business on Broadway from 1871 through 1910, when Carr died and left the management of the business to his partner.

Pictured above is the Father Anderson home on the corner of May and Douglas Street, built around 1885. Dan and Anna Anderson are seated on the porch. Daniel Anderson was a successful grocer, as well as a dry goods and shoe merchant, in Mount Pleasant from 1884 to around 1900. By the turn of the century, Mount Pleasant was home to several such beautiful houses, owing to the prosperity of its business community. At Anderson's store, pictured at right, customers could purchase a variety of items, from soap to shoes to Singer sewing machines.

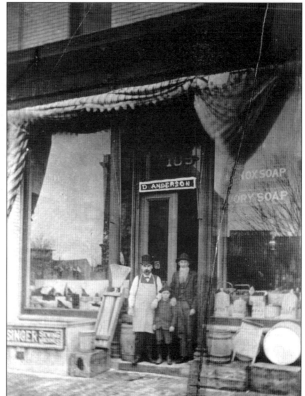

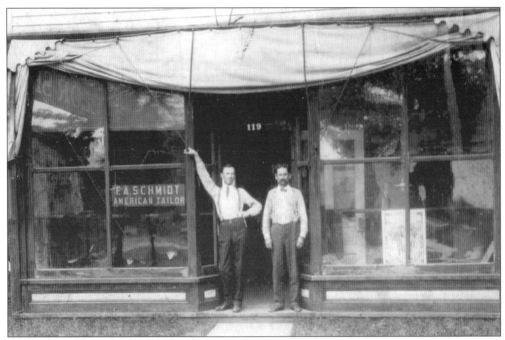

F.A. Schmidt's store was reputed to be a cut above the rest. The German-born tailor took great pride in pronouncing himself an "American Tailor" on the sign outside his store, which opened for business in Mount Pleasant in 1894.

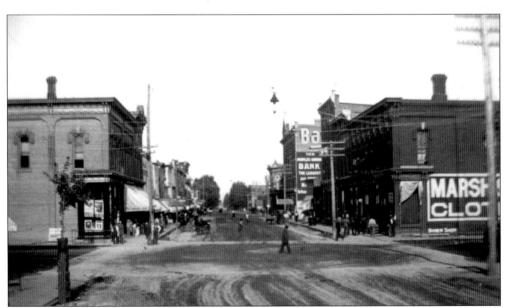

The well-dressed Mount Pleasant man of the 1890s was likely to buy his clothing from Marsh & Lewis, the city's premier men's clothier for many years. L.N. Marsh and W.E. Lewis began their business together in 1889 and were successful enough by 1895 to warrant moving into the prime location at the corner of Broadway and Main formerly occupied by J.H. Doughty. The Marsh & Lewis store is on the right in this view looking east down a muddy Broadway, which would remain a dirt street until well after the advent of the automobile.

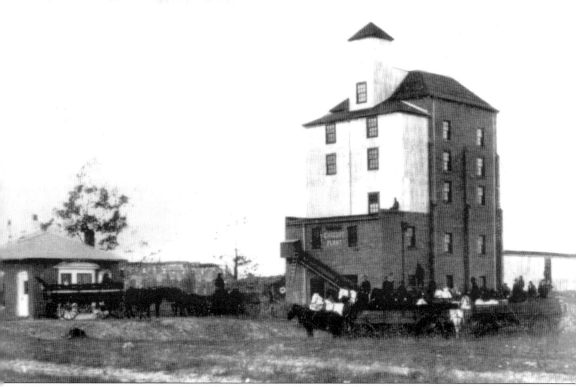

Chicory, at one time a popular substitute for coffee, made headway as an important local agricultural product in the early 1900s. E.B. Muller & Co. opened a chicory factory in Mount Pleasant to facilitate the processing of the crop and to encourage area farmers to envision chicory as a profitable alternative to other crops.

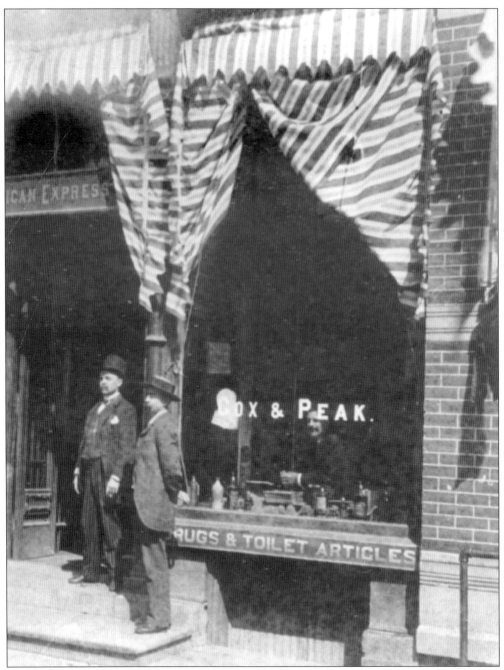

Cox and Peak's store, on the north side of Broadway, was the foremost drugstore in Mount Pleasant for many years. W.W. Cox established himself as the town's preeminent druggist in 1884 and some time later partnered with Peak.

Immediately next door to Cox and Peak, J.C. Freeman operated a jewelry store for part of the 1890s. Freeman was known for the fine quality of his merchandise, which included not only jewelry but watches, clocks, and diamonds. Freeman's store was located within a section of buildings known as the Devereaux block.

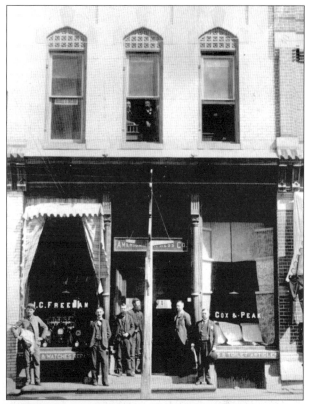

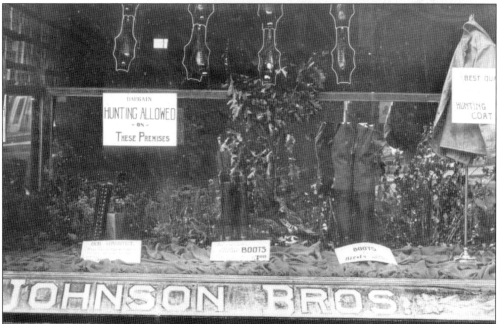

Johnson's sporting goods store was known around Mount Pleasant for its elaborate window displays, such as the one above, proclaiming "bargain hunting allowed on these premises." The displays usually featured an assortment of firearms and hunting apparel.

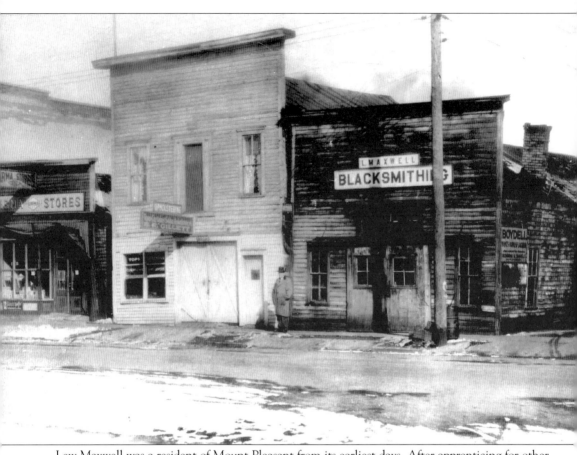

Lew Maxwell was a resident of Mount Pleasant from its earliest days. After apprenticing for other blacksmiths in the early 1870s, he built and opened the smithy shown here on Washington St. next to B.R. Gillett's upholstering store in 1876. The business remained in operation for several decades.

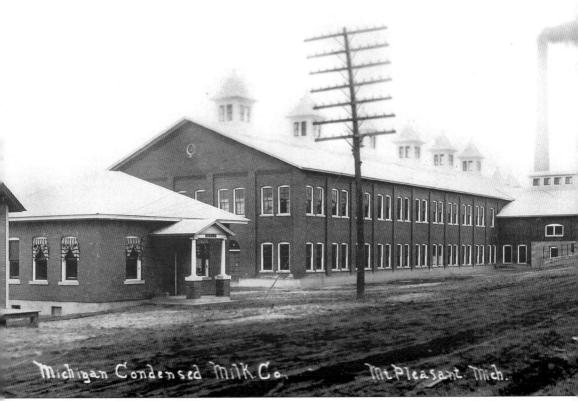

One of the most important businesses in early Mount Pleasant was the condensed milk factory on Broadway St. The Borden Company opened the factory in 1908 in typical Mount Pleasant fashion, with a party and a band. The community welcomed the business with open arms, as it meant many new jobs and an immediate market for the milk of local farmers.

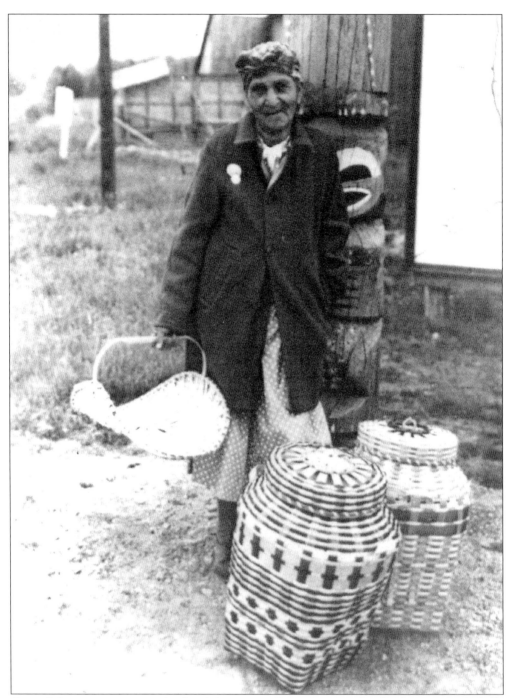
One of the most important (and only) sources of extra income for families on the Isabella Reservation near Mount Pleasant was the sale of black ash baskets such as those pictured here. Black ash basketry is a traditional Chippewa Indian art form and has served for many generations as a source of cultural pride as well as a cottage industry. Baskets produced by members of the Saginaw Chippewa tribe around Mount Pleasant were displayed in various World's Fair Expositions in the earlier part of the 20th century. (Photo courtesy of Ziibiwing Cultural Society.)

Many Saginaw Chippewa people were skilled in the production of snowshoes. The production, sale, and use of snowshoes was just one way that the Chippewas utilized traditional skills to fashion a living in the changing economy and circumstances of the mid-19th century. In this photo of more recent vintage, R.L. Wooley observes Saginaw Chippewa tribal members Smokey Joe Jackson and Willis Jackson Sr. using traditional methods to produce a pair of snowshoes. (Photo courtesy of Ziibiwing Cultural Society.)

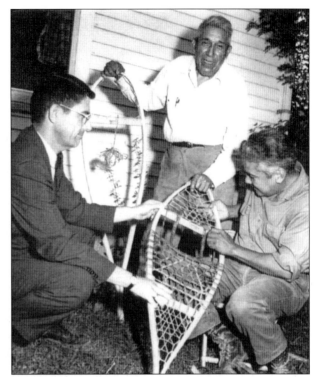

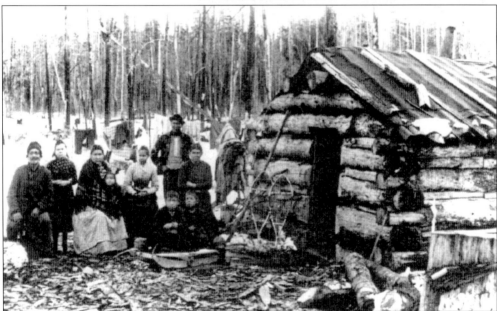

Living on Isabella Reservation lands during the period from 1854 to 1954 usually meant coping with abject poverty. Discrimination and a chronic lack of funding for education, health services, and infrastructural development created a situation which presented few economic opportunities to members of the Saginaw Chippewa tribe. Makeshift tar paper shacks, such as the one pictured here, were not uncommon housing structures in the Mount Pleasant area. (Photo courtesy of Ziibiwing Cultural Society.)

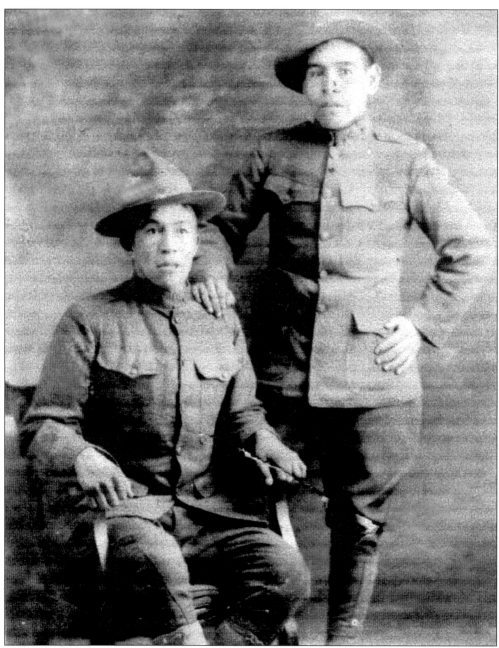

Pictured here are two unidentified men from the Isabella Reservation sporting their World War I "doughboy" uniforms. Although questions continued to surround the Saginaw Chippewa Indians regarding the rights, duties, and status of their U.S. citizenship, many from the Isabella Reservation willingly volunteered for military duty. During the Civil War, several men from the Isabella Reservation served in Michigan's Company K, a special Indian-only company consisting of trained sharpshooters. Historians have had a more difficult time documenting Indian participation in World War I because the practice of separate Indian companies was discontinued and Indian men were not designated as such in War Department records. (Photo courtesy of Ziibiwing Cultural Society.)

Willis Jackson Sr., later an influential leader among the Saginaw Chippewas, stands proud in his Lieutenant's Uniform at Carlisle (Pa.) Indian School in this photo dated June 20, 1915. Prior to the U.S. Entry into World War I, War Department officials had debated whether or not to maintain the policy of separate companies for Indians. Although they decided against it, they did determine that Carlisle would serve as an "Indian West Point" where Indian men could be trained separately for combat. (Photo courtesy of Ziibiwing Cultural Society.)

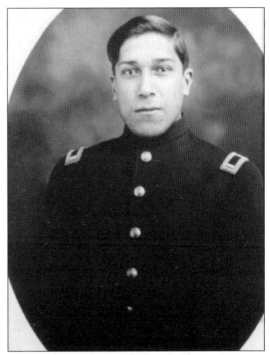

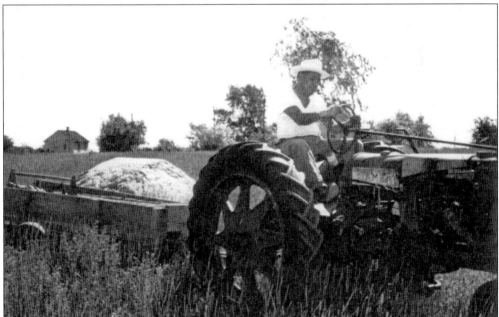

True to the U.S. government's mid-19th century vision of transforming Indians into sedentary agriculturalists, many of the Saginaw Chippewas who settled on the Isabella Reservation took up farming, often because it was the only viable economic pursuit available to them. Among the stipulations of the 1855 and 1864 treaties between the U.S. and the Chippewas were provisions for agricultural implements and training. Dan Jackson, shown here riding his tractor near Mount Pleasant in the 1950s, is indicative of the legacy of the U.S. policy encouraging farming among reservation Indians. (Photo courtesy of Ziibiwing Cultural Society.)

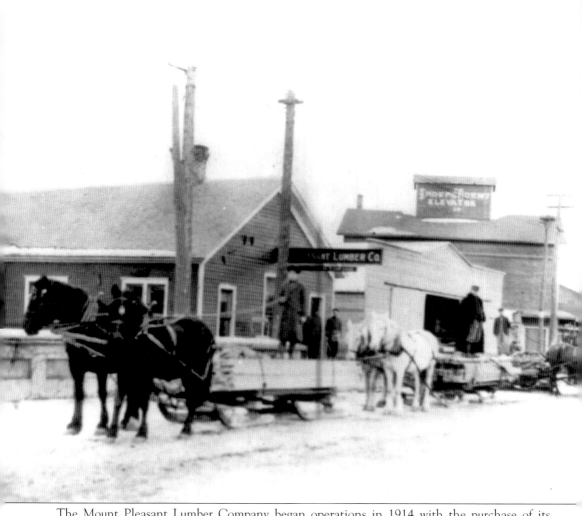
The Mount Pleasant Lumber Company began operations in 1914 with the purchase of its predecessor, the Hendricks Lumber Co. Their first advertisement featured a 900 square foot bungalow with living room, dining room, kitchen, two bedrooms, hall, bath, vestibule, back porch, and large front porch, with Western Red Cedar shingles, all for $575! Pictured here are draft horses pulling a lumber shipment on sleds.

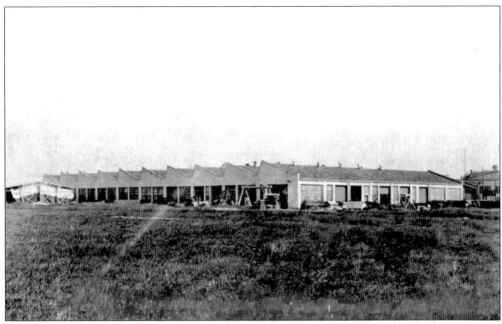

An interesting manufacturing concern in early Mount Pleasant was the business known as the Transport Truck Company. Capitalized in part through the purchase of stock by the citizens of Mount Pleasant, the company located there in 1918. By 1919 they had constructed a factory, pictured above, on Pickard St.

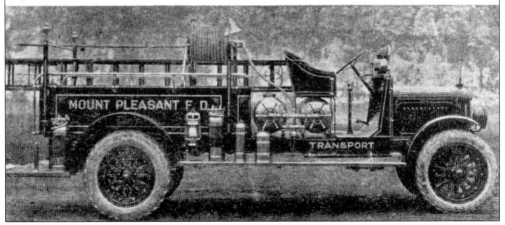

Mount Pleasant's first motor-powered fire engine came to the city courtesy of the Transport Truck Company in 1919. Until then, fire engines were drawn by horses. Some of the features that made the Transport Truck so famous were listed in an advertisement at that time: Continental Engine, Clark Internal Gear Rear Axle, Eisemann Magneto, Stromburg Carburetor, Detroit Pressed Steel Frames, and Goodyear Tires. "Go over the Transport specifications," the ad directs, "Better still, see the truck. . . . Then you will know why the Transport stays on the job."

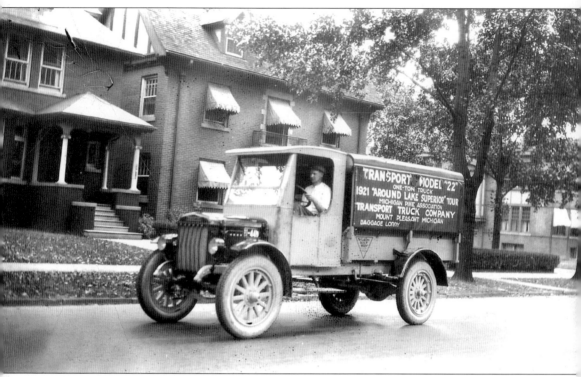

The Transport Truck Company people were master promoters. In a 1921 effort to generate publicity, the company sponsored an "Around Lake Superior" tour to demonstrate the toughness of their product. Among the convoy of Transport Trucks to participate in the tour was this "Model 22 one-ton baggage lorry."

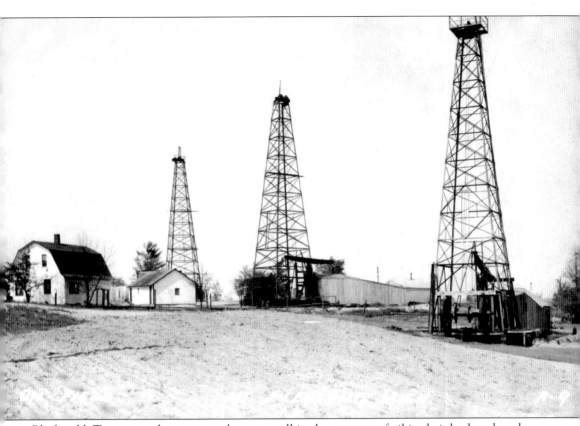

Black gold, Texas tea, whatever you choose to call it, the prospect of oil in their backyard made many Mount Pleasant residents see dollar signs. In 1928 a strike by the Pure Oil Company east of town triggered a rash of drilling activity in the areas north and east of Mount Pleasant. Wealth literally shot from the ground as one after the other, farmers' fields yielded productive wells.

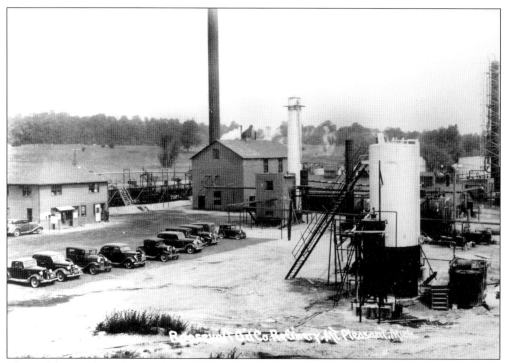

The "oil boom" brought people and money into Mount Pleasant and served as an important economic uplift at a time when prosperity was waning for most of the rest of the country. New businesses, such as the Roosevelt Oil Refinery, meant more jobs for Mount Pleasant citizens and a new source of revenue for the city.

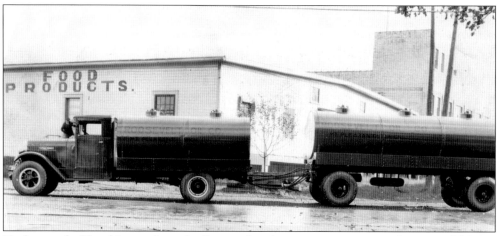

Tanker trucks like this one from the Roosevelt refinery were common sights around Mount Pleasant from the late 1920s onward.

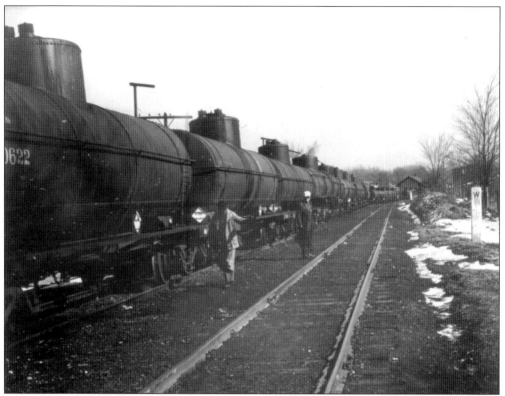

To get the crude oil from the well to wherever it was to be processed, workers dug trenches and installed pipelines running from the well to holding tanks, which were often located along Isabella County's railroad lines. The oil was then carted off on railcars specially fitted for the purpose.

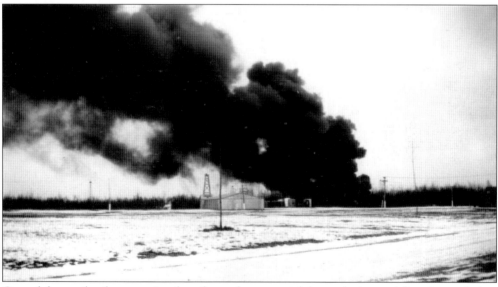

One of the perils of prospecting for oil was the potential for explosion and fire. An explosion at a well near Mount Pleasant in 1931 injured 30 people and killed 9. Oil workers knew that theirs was a hazardous occupation.

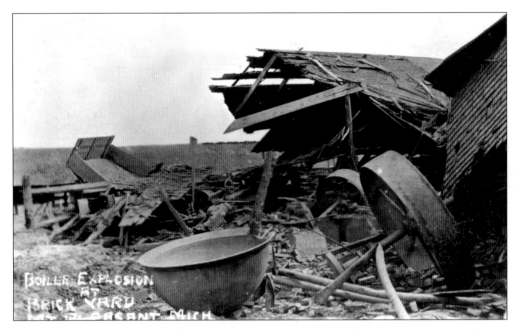

Murphy's Law—anything that can go wrong, will go wrong—applies even in a fortunate city like Mount Pleasant. Above, we see the aftermath of a boiler explosion at the brickyard. Below, it looks like someone slightly overestimated the strength of that bridge over the Chippewa.

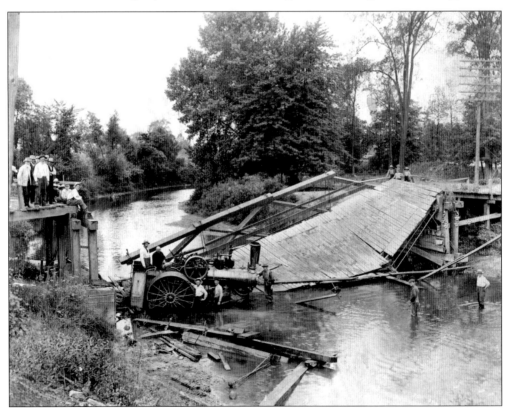

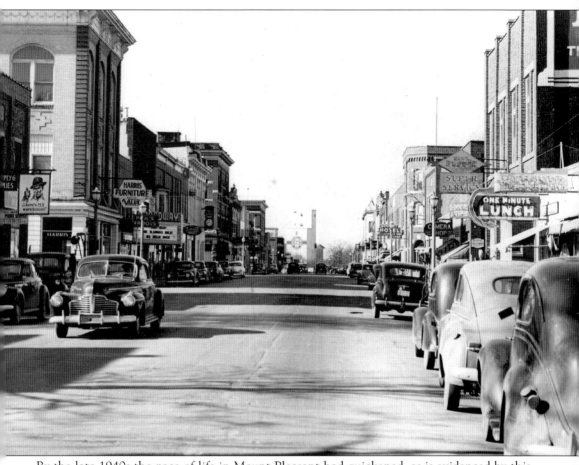

By the late 1940s the pace of life in Mount Pleasant had quickened, as is evidenced by this view looking west down Broadway. Business was booming, and businessmen in a hurry could stop in for a "one-minute lunch." Townspeople seeking quality entertainment on the day this picture was taken might have gone to the Broadway to catch Cary Grant in *Mr. Blandings Builds His Dream House*.

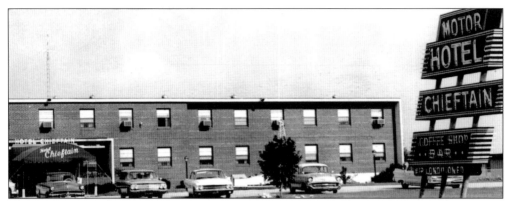

The refined luxury of hotels like the Bennett House eventually gave way to a new line of businesses known as motor hotels. The Chieftain Motor Hotel in Mount Pleasant may not have been as beautiful as the Bennett, but it was cheap, quick, and easy, and suited the needs of an increasingly mobile culture. As its sign proudly proclaimed, it had air conditioning.

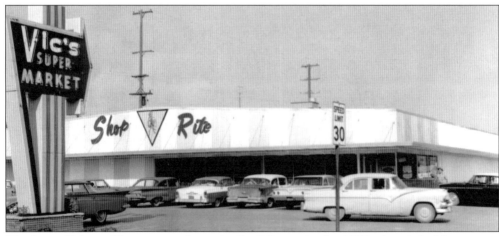

The face of Mount Pleasant was dramatically different in the 1950s than it had been even a decade earlier. Consumers demanded convenience and variety, and nowhere was this better evidenced than in the rise of "supermarkets." Vic's Shop-Rite was one of the first supermarkets in Mount Pleasant. Those familiar with the city will recognize this location as the present site of Ric's supermarket.

Three
OUT ON THE TOWN

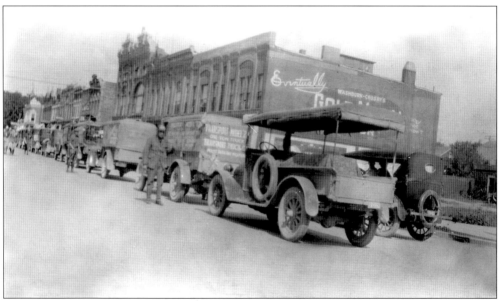

"Saturday, July 3d, the day set for the celebration of our national Independence at Mount Pleasant, proved to be a bright and auspicious day. At sunrise the sound of the firing of salutes awakened the slumbering community. At a very early hour the rumbling of wagons and buggies indicated that the people had commenced to arrive, and the din, clatter and dust occasioned by the constant arrival of the crowd, did not cease until the village was filled with a throng of people."—July 7, 1880 article from the *Enterprise*.

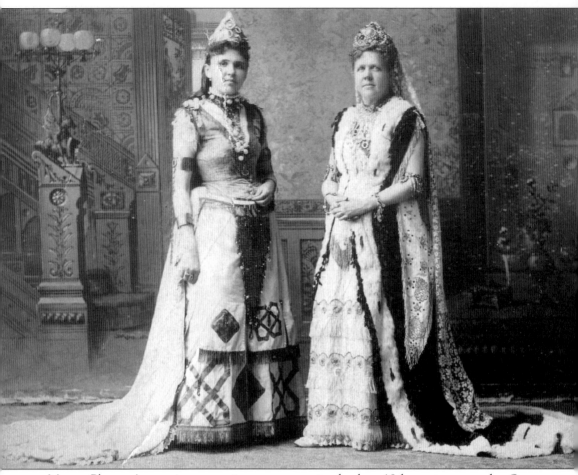

Mount Pleasant's premier entertainment venue in the late 19th century was the Opera House, located above the First National Bank at the corner of Broadway and what is now University Ave. The Opera House hosted dramatic performances, concerts, dancing, public meetings, and sometimes even opera. For a period, the Union School held its graduation ceremony in the establishment. Sold-out shows were the rule rather than the exception. The costumed ladies pictured here bask in the afterglow of what was undoubtedly another fine performance at the Opera House.

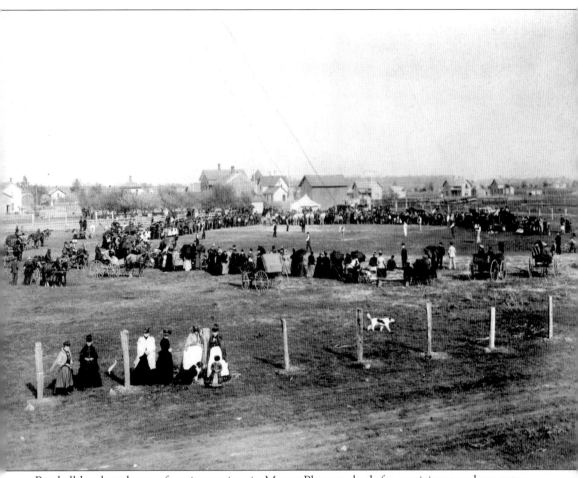

Baseball has long been a favorite pastime in Mount Pleasant, both for participant and spectator. The fields at Island Park and elsewhere in the city were a popular location for games. Baseball as it was then played was very different from today's game; the pitcher was for the most part an afterthought, and the hitter's job, rather than hitting the ball for distance, was to put the ball in play. Defensive skills and speed on the bases were the most important qualities a player could possess. In this 1890 photograph, a crowd is gathered for an afternoon game in Mount Pleasant.

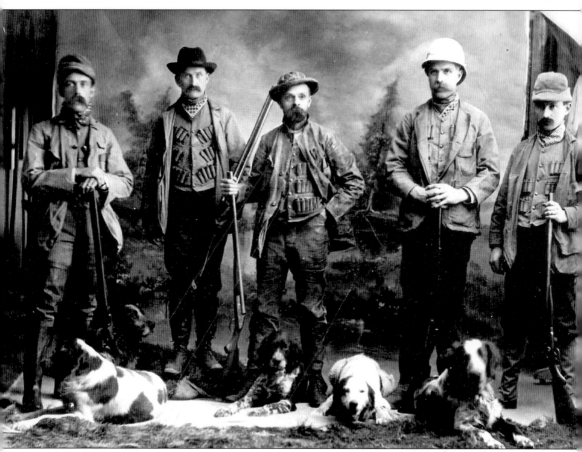

Hunting was one of the most popular pastimes for the men of Mount Pleasant. In its earliest days, Isabella County was home to an important squab roost, making squab, or passenger pigeon, a favorite target for hunters. Passenger pigeons were at one time the most plentiful species of bird in the United States, but by the 1890s they were gone from Michigan and soon after that, the species was driven to complete extinction. Shown here are, from left to right: Chester Gorham, unidentified, Dr. Cimmaron, Charles McKinney, and P.C. Taylor in full hunting party attire.

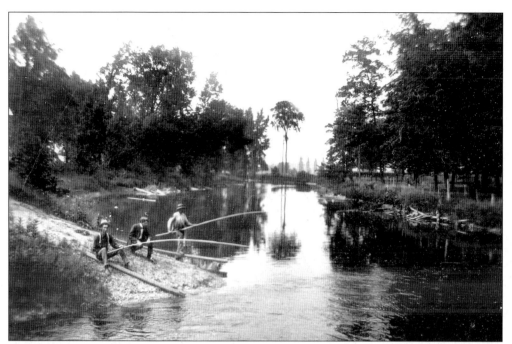

Fishing, while never economically important to the people of Mount Pleasant, has served as a popular sport. From the times of initial settlement along its banks, the Chippewa River has yielded trout, bass, and suckerfish to those patient enough to learn its "secret spots."

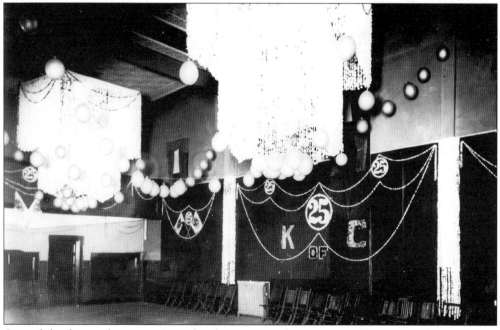

One of the fraternal organizations that became popular in Mount Pleasant in the early 20th century was the Knights of Columbus. The Mount Pleasant Council of the K of C was chartered in 1908 with 70 members. Membership at the time was limited to those who were members of the group's associated church.

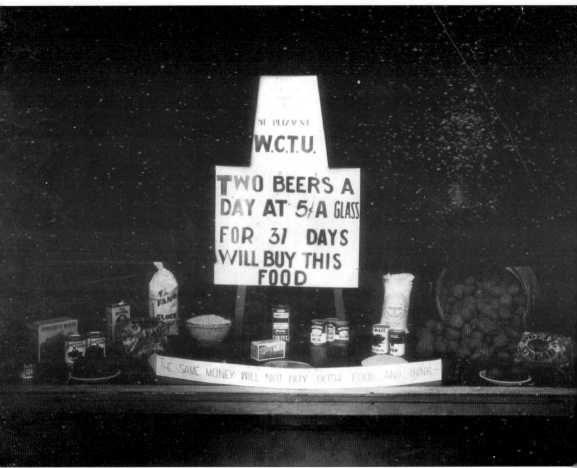

The Women's Christian Temperance Union was a social reform group that grew out of the Women's Temperance Crusade of the 1873. The women of the Temperance Crusade were noted for their unorthodox tactics, such as walking into saloons and singing hymns in an effort to encourage saloonkeepers to abandon the sale of liquor. It was largely due to the efforts of the WCTU that Congress passed the 18th Amendment in 1919 prohibiting the manufacture and sale of alcoholic beverages. Shown here is an anti-beer sign produced by the Mount Pleasant chapter of the organization.

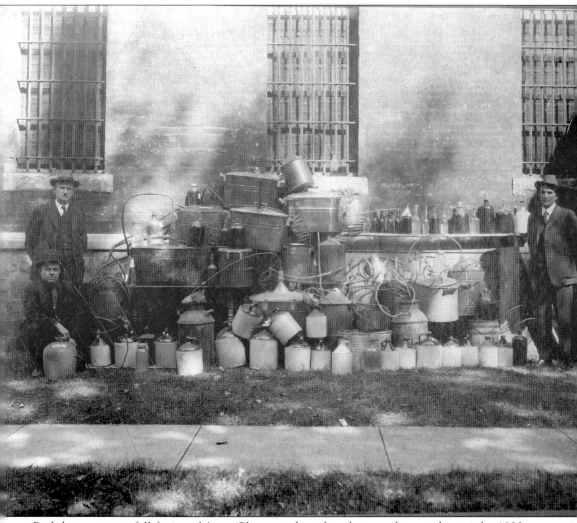

Prohibition was in full force in Mount Pleasant when this photograph was taken in the 1920s outside the city jail. This collection of stills shows and was compiled by, left to right: Sheriff Parm Landon, Under-sheriff George Richmond, and Deputy Frank Grinnell. Congress would not repeal the law prohibiting liquor until 1933, when they did so with the 21st Amendment.

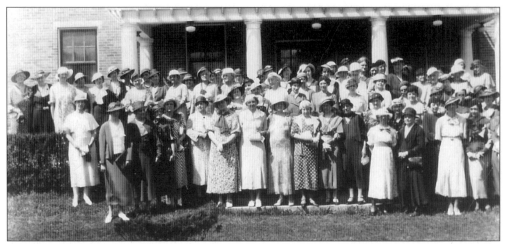

In many cases, women's groups were responsible for bringing about important social and civic reforms. The Ladies' Library, Literary, and Music Association, for example, was instrumental in bringing about the construction of Mount Pleasant's first public library. Women's clubs, such as the one pictured above, were an important conduit to social intercourse and represented an effective and accepted way for women to give voice and weight to their political opinions.

This is the Mount Pleasant chapter of the Daughters of the American Revolution. The D.A.R. was a "patriotic" organization founded in 1890; to be a member, a woman had to prove a direct hereditary lineage from someone who had fought in the Revolutionary War. The outcome of their membership policies until recently was an elitist, almost exclusively white organization. The official D.A.R. motto is "God, Home, and Country" and the organization lists as its priorities historic preservation, patriotism, and education.

By the turn of the last century, more and more women across the country were taking employment outside the home. Change was slow to come to rural Mount Pleasant, however, and occupations for women were extremely limited. Some became teachers; others ran shops such as Ella Fishley's millinery shop on South Main St. Most worked in their own homes, cooking, keeping the house, and looking after the children, sometimes bringing in extra income to the family by sewing or producing small items for market. The group of ladies pictured here represents the "high society" of Mount Pleasant and would have deemed it undignified to take employment outside the home. As their husbands lamented, certain ladies were equally repulsed by work *inside* the home!

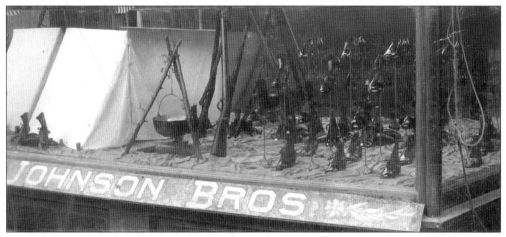

In this Johnson's display, the sign in the window welcomes local members of the G.A.R., or Grand Army of the Republic. The G.A.R. was founded in 1866 by a group of Civil War veterans who were "dedicated to preserving the memory of their fallen comrades." In Mount Pleasant and elsewhere, the group gained a great deal of influence in politics, owing to its large membership of loyal Republicans. Among the organization's achievements were the establishment of Memorial Day as a national holiday and a successful lobbying effort for the payment of veterans' pensions. The last Michigan member of the G.A.R. died in 1948 and the last national member in 1951.

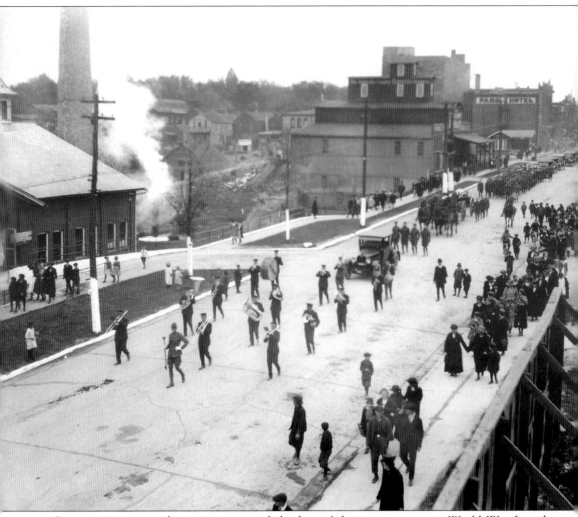

Communities across the nation mourned the loss of their young men in World War I, and Mount Pleasant was no exception. Pictured here is a soldier's funeral procession filing past the Borden condensed milk plant on Broadway in 1917.

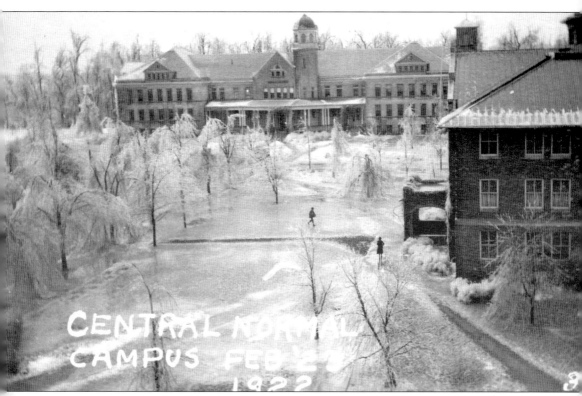

The giant sleet storm of February 22, 1922, was probably the worst storm to ever hit Mount Pleasant. As ice collected on trees, power lines, and anything else exposed to the sleet, the weight became too much to bear. Power lines snapped and trees everywhere lost branches and limbs in wholesale fashion. This picture shows the Central Normal campus after the storm.

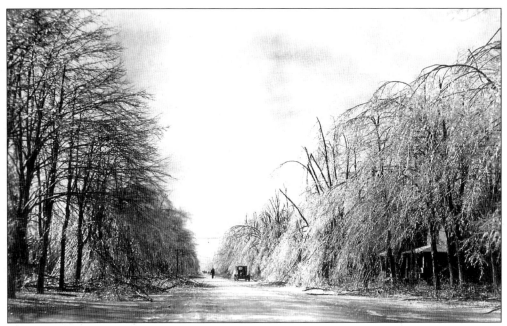

The city was paralyzed for days as roads were frozen over, the trains stopped running, and businesses were left without power. For the trees it was worse—they would need years to recover from the severe damage.

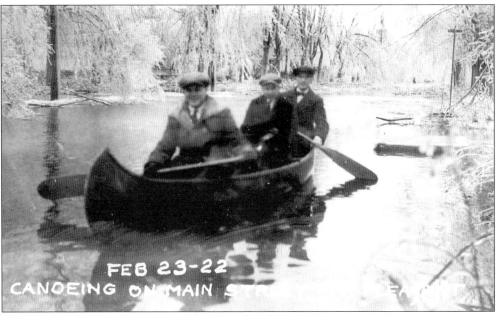

The people of Mount Pleasant are a resilient bunch, and they responded to Mother Nature's attacks with good humor. The storm was followed by flooding, and what better opportunity for a late-season canoe trip? This photo was one in a series produced by local photographer Francisco, who documented the storm in postcards.

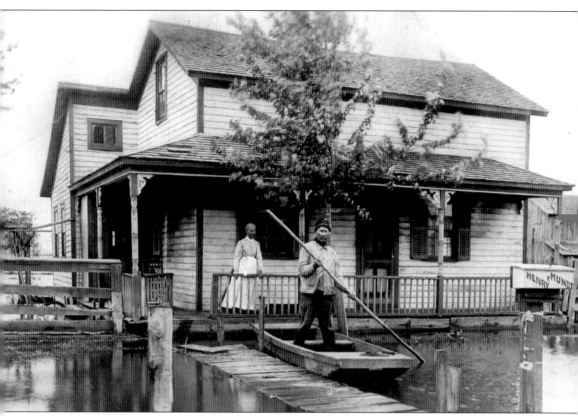

Living alongside the Chippewa had its advantages and its disadvantages. During years of heavy spring thaw, the river would sometimes overflow its banks, forcing Mount Pleasant's residents to deal with the situation as best they could. This couple seems to be well-prepared.

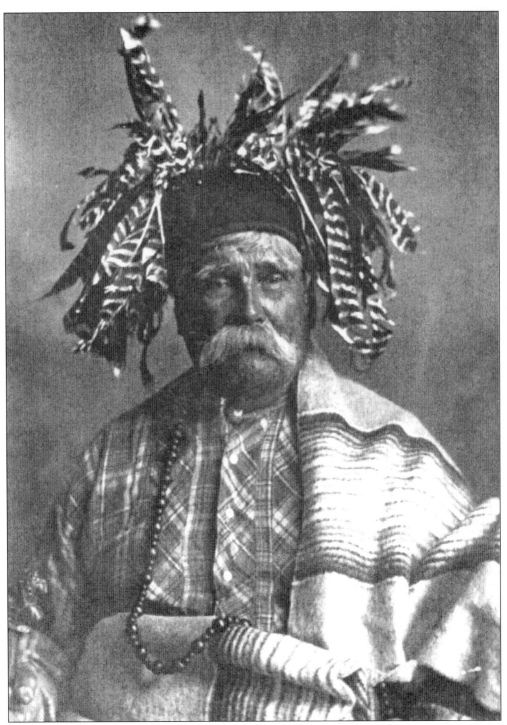

Jacob Tipsico was among the most popular residents of Mount Pleasant during the late 1800s. Once a great athlete, Tipsico supported himself in his later years with monies he obtained by selling photographs of himself in traditional Indian dress. Tipsico regaled his listeners with stories about his valiant exploits in battle earlier in his life.

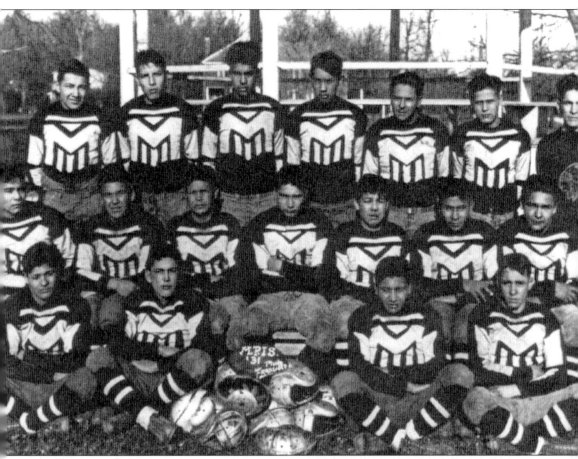

The Mount Pleasant Indian School competed against other schools in various athletic contests, including football. Pictured here is the 1931 team made up of eighth and ninth grade boys aged 14 to 16. Fights were a frequent occurrence during the football games, especially when the school was playing against such hated rivals as Reed City or the Lansing Reform School.

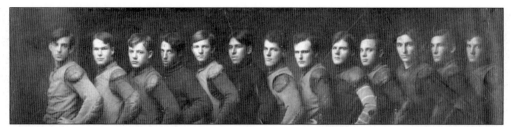

Mount Pleasant's High School has a long history of success in athletics. This group of footballers won the "championship of the Lower Peninsula of Michigan." Pictured are, from left to right: Bruce Stickle, quarterback; Jim Jamison, right half back; John McNamara, substitute left guard; George Wilmot, left end; Charles Crandell, substitute end and halfback; Joseph Stevens, center; Judd Brubaker, left tackle; Charles Dunlap, left halfback; Walter Russel, right end; Phil Dusenbury, right guard; Ben Dersnah, right tackle; Gordon McBain, left guard; and Ray Bunn, fullback.

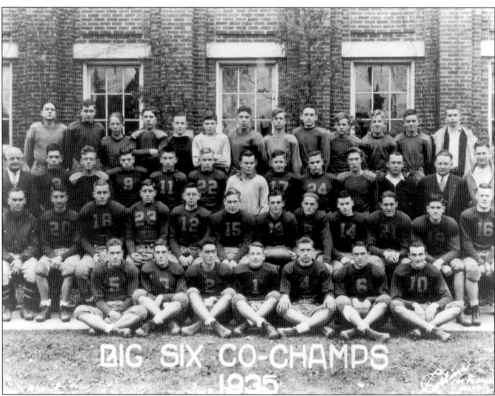

Following in the proud tradition of Mount Pleasant athletics, this group of young gentlemen brought home the "Big Six" co-championship for Mount Pleasant High School in 1935. Pictured are, from left to right: (front row) Dale Kirckonell, Merle Meyers, Don Water, Jack Benford, Bob Scholl, Bill Donaldson, and Bob Nutters; (second row) Coach Pelligam, Bob Visger, Bob Ball, John Alexander, Fred Scholl, Bus Wariner, Denslow Sargent, John Merrifield, Don Sibley, Schmidt, Don McRae, and Frank Miller; (third row) Superintendent Ganiard, George Wheller Jr., Bob Grinnell, John Sisco, Bub Visger, Herb Hood, Lyle Campbell, Mickey Mackinze, Bob Fiedler, Mr. Wendt's nephew, Gassy Heggerman, Principal Mr. L.C. Wendt, and Coach Arlie Osborn; (fourth row) Bill Corbin, Curt Ross, "Stub" Paullin, Conroy, Lee Sibley, Phil McGill, Lyle Baskerville, Paul Sargent, Ed Donaldson, Bud Trussell, Bud Benford, Charlie Dickerson, and Max Wardrop.

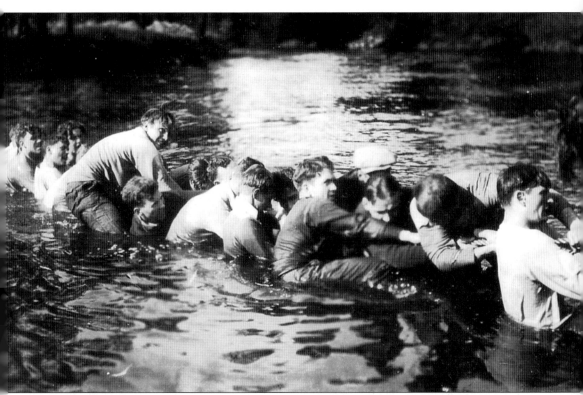

Never let it be said that the students at Mount Pleasant High School didn't know how to have a good time. This photo dated May 26, 1927, shows a group of young men fighting for bragging rights in the annual Junior-Senior Tug-of-War. Unfortunately, the results of this showdown were not recorded; the only certainty is that everyone ended up wet.

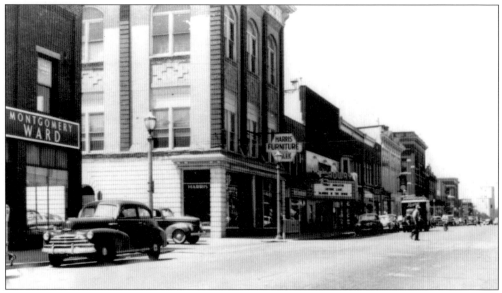

The Broadway Theater has been entertaining Mount Pleasant audiences since it opened in the early 1910s, possibly under the name "The Vaudette." The theater initially featured a mix of vaudeville and films and gradually transitioned away from vaudeville performances. *Thunder* with Lon Chaney was the last silent film shown at the Broadway, on November 10, 1929. The theater made headlines in the early 1940s with the showing of *Mom and Dad*, a sex hygiene film including, among other taboo subjects, the birth of a baby. The film was condemned by the Catholic Church and featured separate showings for men and women. (Information courtesy of Friends of the Broadway.)

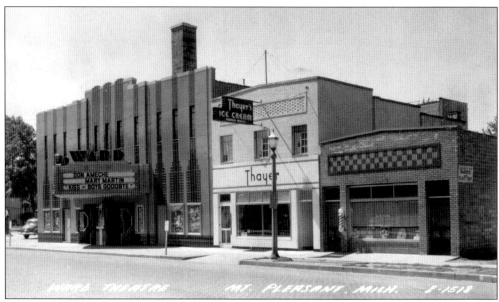

By the 1940s, the Ward Theater on Main St. had joined the Broadway to become one of Mount Pleasant's two most popular movie houses. A moviegoer on the date this picture was taken might have enjoyed the current feature, Don Ameche and Mary Martin's *Kiss the Boys Goodbye*. Both the Ward and Broadway theaters continued to operate as full-time cinemas well into the 1990s.

Four
SCHOOL DAYS

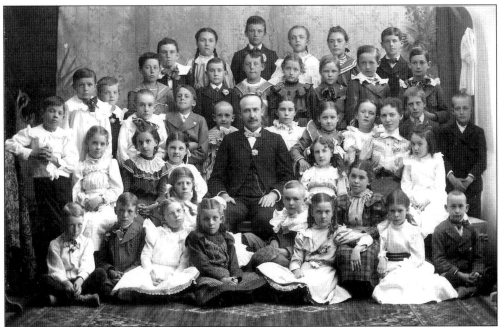

"If we go back to the early settlement of the county and examine the means of education within the reach of the children, that were destined to form one of the principal elements in our social system, we shall necessarily find it crude and uncongenial. Nothing to invite the youth but a log building and plank seat, without map or chart, and almost without a teacher; with no guide through the woods but an Indian trail or a blazed line. But, crude and uninviting as it was, it found young America with his usual amount of force and will, equal to the task. . . ."—Isaac Fancher, in *Past and Present of Isabella County*, concerning education in Isabella County.

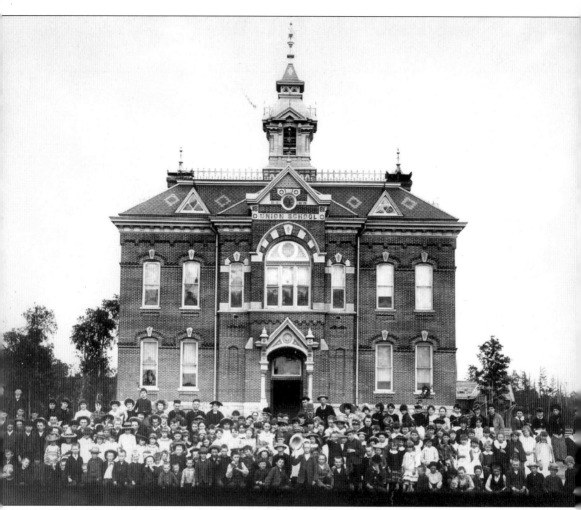

The Union School building was Mount Pleasant's first high school. Constructed at a cost of $17,000 in the spring of 1885, its size and elegant construction were indicative of the growth Mount Pleasant had experienced in its first few decades. Graduates of the school were admitted without examination to any college or university in Michigan. In addition to classrooms, the school featured a research library, a reading room, science laboratories, and a large gymnasium.

The West Side School hosted the young children of Mount Pleasant's rural west side for many years. One of the best-loved teachers at the school was Miss Mary McGuire, who taught students from first through fourth grades. Today, McGuire's name graces an elementary school in Mount Pleasant.

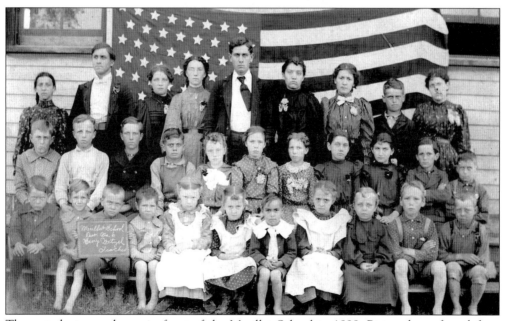

These students are shown in front of the Merillat School in 1898. Pictured are, from left to right: (first row) Floyd Stilgenbauer, Cecil Graichen, Fred Stilgenbauer, Ralph Graichen, Ella Johnson, Myrta Horre, Homer Zingery, Carrie Hibbard, Gladys Atkins, Don Wilmot, and Harry Atkins; (second row) Lauren Neaser, Ed Merillat, Glen Stilgenbauer, Earl Zingery, Flossie McFarren, Alta Wilmot, Dew Struble, Laura Meyers, Carrie Meyers, Ray Stilgenbauer, and Roy Zingery; (third row) Edith Merillat, Harry Wetzel (teacher), Alice Hibbard, Nellie Mirer, Walter Horn, Etta Vorirel, Jossie Hibbard, Oliver Zingery, and Minnie Stilgenbauer.

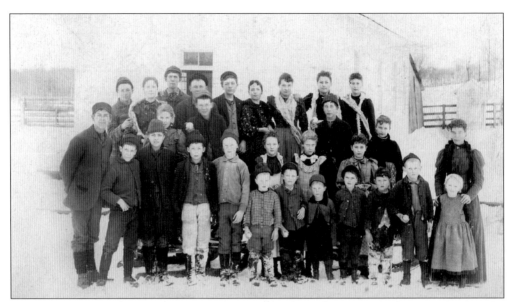

The Sherman School class of 1894–1895 is shown here. Teacher Laura Wiley wrote that she "enjoyed these pupils—hard work with so many." In late 19th century Mount Pleasant, teaching was one of the few accepted occupations for women outside the home.

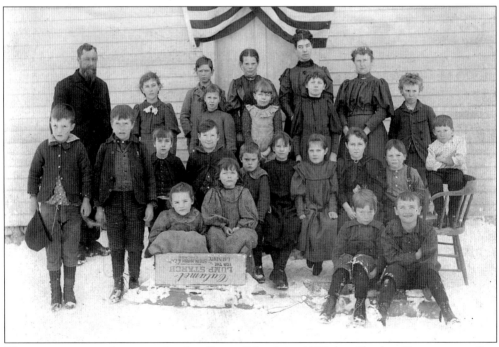

This picture was taken outside the Speer School in 1897 by Charles Gage, a traveling photographer. According to an inscription on the back of the photo, "Mr. Gage, an old batchellor [sic], use [sic] to visit all the schools around. He happened to be visiting me that day. He was master of ceremonies at my wedding June 12, 1901. He use [sic] to tell every young man when he got to be 21 years old to look around, he said, I made an awful mistake, now I'm too old! These were interesting children."

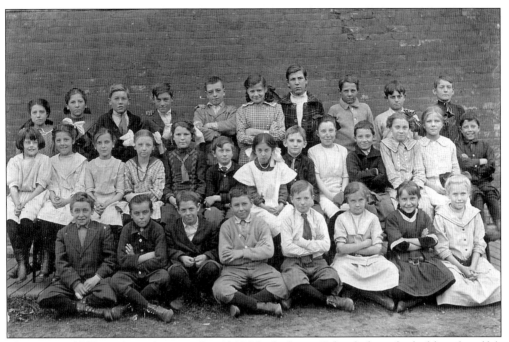

The group of fifth grade students in this 1913 Maple Street School photo looks like a handful. Luckily Mount Pleasant had an abundance of good teachers, as the Normal School provided a regular supply of trained professionals.

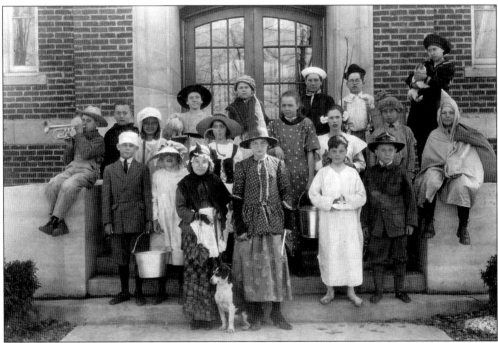

In this 1919 photo of an unidentified Mount Pleasant school class, students take advantage of an opportunity to show off their Halloween costumes. The Mount Pleasant school system was known for the high quality and standards of achievement attained by its students.

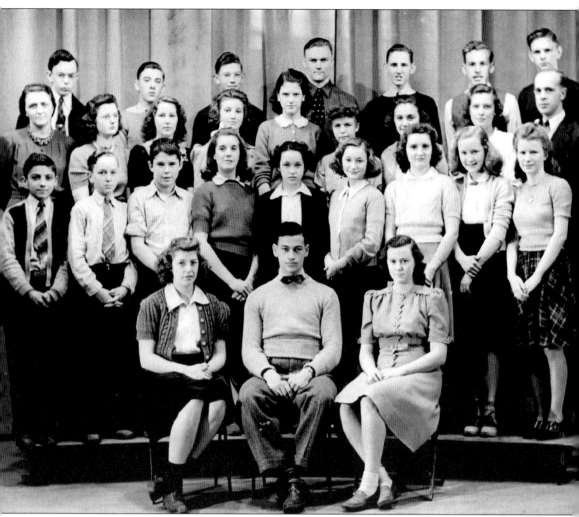

Mount Pleasant's high school produced many fine graduates, some of whom went on to become community leaders. Fifth from the left in the top row of the picture above is future probate judge Walter Horn, and farthest to the right in the second row is future register of deeds Roy Zingery. Others pictured include Edward Merillat, Minnie Stilgenbauer (later Fuller), Glen and Ray Stilgenbauer, Caroline Meyer (later Powell), and Ella Johnson (later Powers).

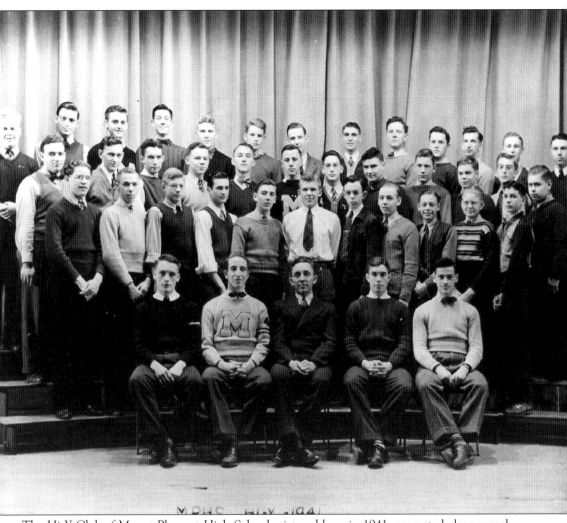

The Hi-Y Club of Mount Pleasant High School, pictured here in 1941, promoted clean speech, clean living, and clean sports. Originally founded by the YMCA in 1889 as a way to promote character among young men, in 1923 a sister organization was founded for young women known as "Tri-Hi-Y." The members pictured here are, from left to right: (front row) Melvin Delwiler, Terry Carey, Mike Muyskens, Robb Wardrop, and Stu Traines; (second row) Don Sodeman, Clark Eldred, Jack Thompson, Russ Huber, Norman Assmann, "Steamer" Clark, Steve Cole, Jack Leonard, Burdette McVey, Charles Archey, and ? Keyser; (third row) Irving "Hippo" Traines, Bob Uttenback, Bill Wardrop, Bill Theunissen, Jack Voorhees, unidentified, Charles Lea, Mark Johnson, Charles Wildermuth, Maynard Johnson, Dewight Danigler, and Elton Wilcox; (fourth row) ? Wilcox, Russ Kenega, Robert Tope, Bruce Amblen, Jon "Swede" Hanson, Robert Hood, Bert Isabell, unidentified, Carl Kepkau, unidentified, John J. Hafer, Ed Prior, and Dick Carroll.

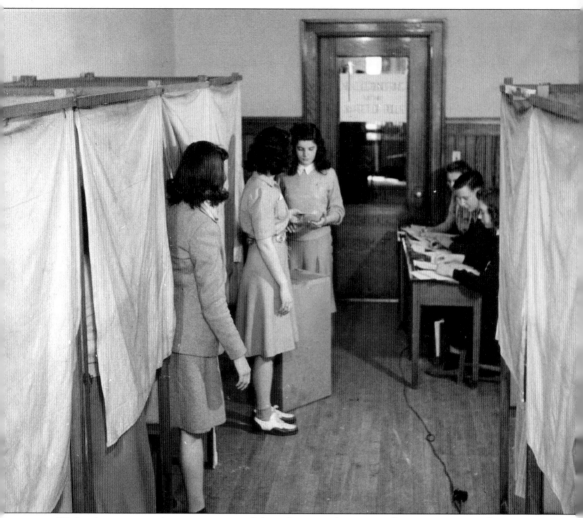
Civic virtue was an important part of the educational program for young men and women in the 1940s and beyond. Exercising the right to vote was considered essential to maintaining democratic ideals threatened by the rise of fascism across the world. Here a group of Mount Pleasant high school girls learn voting etiquette as they participate in a school election.

U. S. Indian School, Mount Pleasant. Mich.

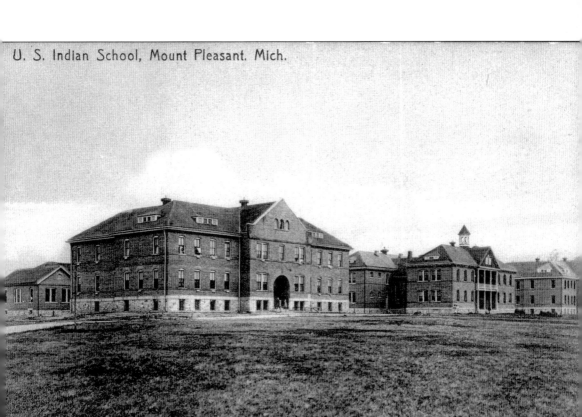

In an effort towards fulfilling treaty stipulations, an Act of Congress in 1891 appropriated funds for the establishment of an Indian Industrial Training School in Isabella County. Due to its central location and sizable contribution to the purchase amount for the school's land, Mount Pleasant was selected as the site. Construction on the main school building was completed in 1893 on a tract of land known as the "Old Mission Farm," just outside the city limits.

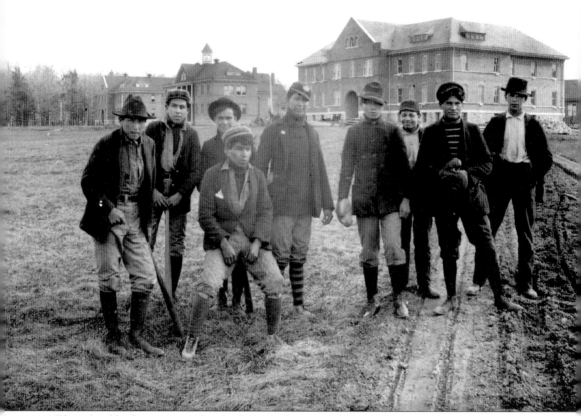

The school had a capacity of around 400 students and featured fairly equal numbers of boys and girls. Some of the students were from the immediate area, but many came from other parts of Michigan, mostly from poorer families which the government felt could not provide the proper environment for their children. Attendance was free and the federal government covered the cost of transportation for all students.

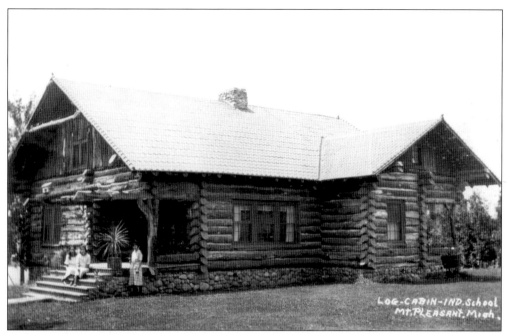

Girls and boys resided in separate dormitories and pursued different courses of study and training. Girls, in addition to their regular classroom work, were taught housekeeping, sewing, laundry work, cooking, or other specialized skills of "domestic science." Pictured here is the domestic science cottage where much of this training took place. The cottage was built of logs from the school grounds—hewn, prepared, and assembled in large part by boys at the school.

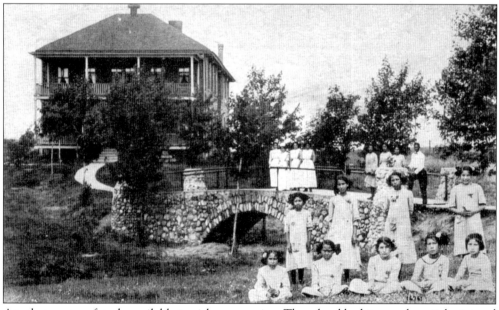

Another course of study available to girls was nursing. The school had its own hospital, pictured above, where nurse trainees learned basic medical care. Students often used the skills they learned at the school to obtain summer employment; for girls this usually meant doing housework, working in laundries or hotels, or in canneries.

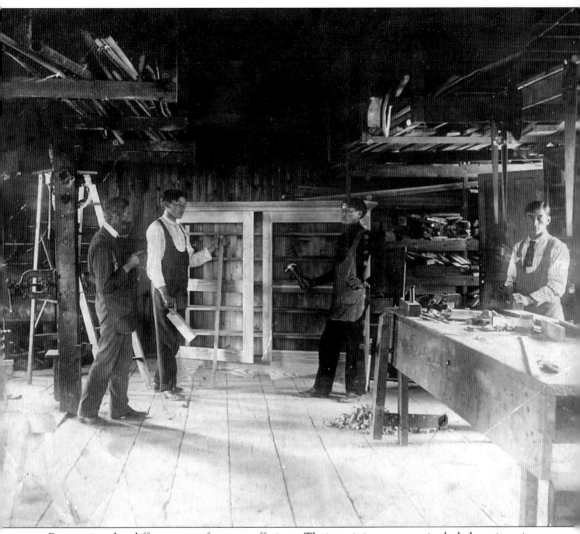

Boys enjoyed a different set of course offerings. Their training courses included engineering, farming, carpentry, baking, shoe mending, and perhaps the most popular trade, tailoring. Boys were able to get summer jobs using their tailoring skills, or working on one of the area's many farms. The school was situated on a productive farm with acreage devoted to a variety of fruits and vegetables as well as numerous fruit orchards.

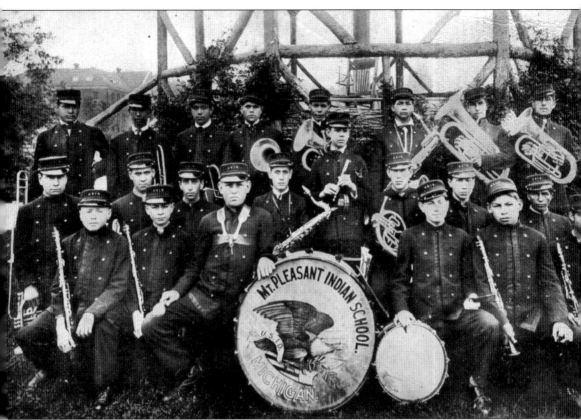

The Indian School band was renowned around Mount Pleasant and was in high demand for parades, ceremonies, and other public events. The school also featured an orchestra of both boys and girls and a girls-only mandolin and guitar club. Each grade also had its own chorus.

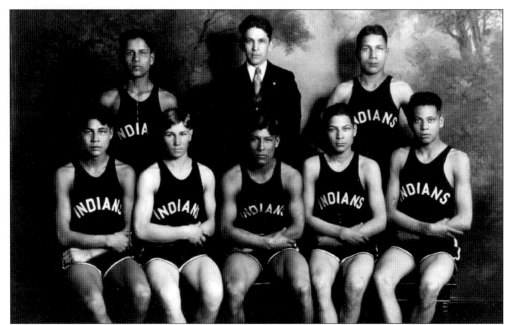

Physical fitness was also part of the curriculum at the Indian Industrial School. Boys were encouraged to participate in baseball, football, basketball, tennis, and skating. Frequently they would play against other students from within the school, but occasionally they traveled to take on other schools.

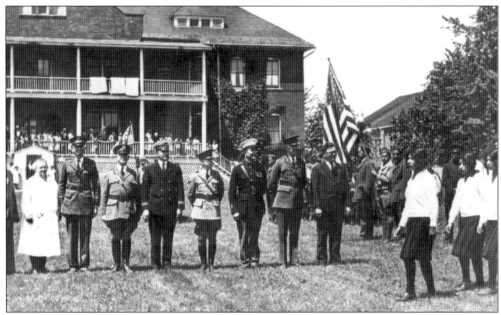

Because the school was a federal operation, students were often gathered together for military review and patriotic demonstrations. As a pamphlet published by the school put it, "the one great aim of this school is to help prepare the Indian boys and girls for the duties, privileges, and responsibilities of American citizenship." Stated more directly, the government wanted to make the students less Indian, and more like what they thought an American should be.

Five
HIGHER LEARNING

"While we have made many changes in the past few years, we feel that we have only begun to develop and to grow. We have a program for the next ten years, calling for more land, a new training school, and more dormitories as well as an educational and spiritual development to keep pace with the rapidly moving civilization in which we are living."—Central State Teachers College President Eugene C. Warriner, June 1928, speaking for the dedication of the new administration building, now Warriner Hall, pictured above.

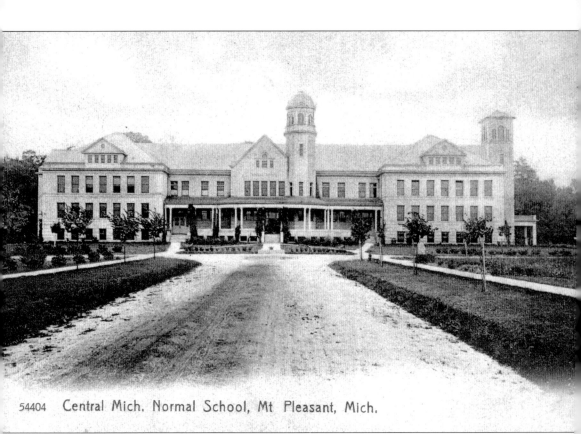

54404 Central Mich. Normal School, Mt Pleasant, Mich.

Today, Central Michigan University stands as a progressive, diverse, first-rate educational institution. It occupies a position of importance in the culture and economy of the city of Mount Pleasant. The growth of the city cannot be understood without giving due consideration to her college. From 1892 forward, they shared prosperity, triumph, and tragedy, and provided the context within which a community flourished.

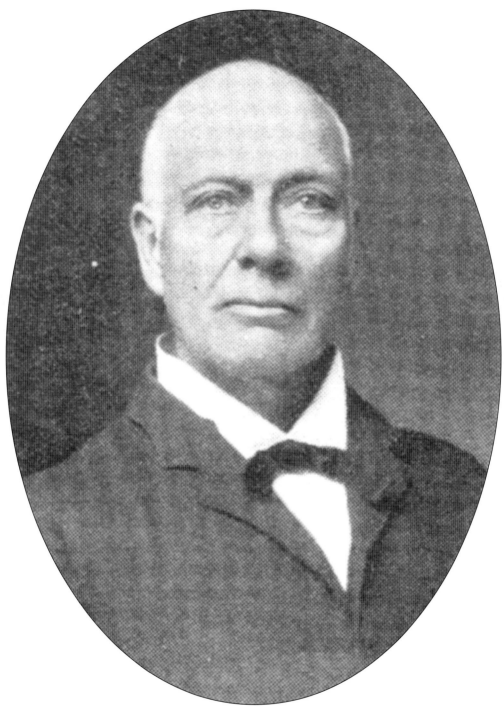

In 1892 a group of citizens led by Judge Samuel W. Hopkins, pictured above, joined together to form the "Mount Pleasant Improvement Company." Their purpose was to build and maintain an institution of higher education. The organization purchased 52 acres of land for $8,000, platting the majority into 224 lots for sale at $110 each and reserving ten acres for the school. The lots sold were assigned not by selection but by chance.

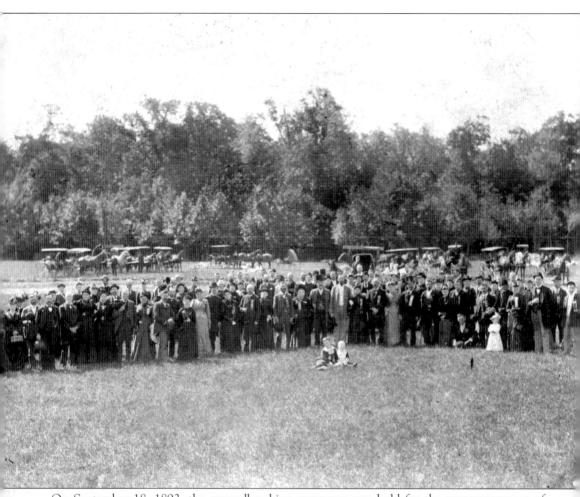

On September 18, 1892, the groundbreaking ceremony was held for the commencement of work on the first building of the "Mount Pleasant Normal and Business Institute," or what was eventually to become Central Michigan University. The school's first principal, C.F.R. Bellows, turned the first sod. Bellows, formerly of the State Normal School at Ypsilanti, was paid $2,000 a year for his work as surveyor and principal.

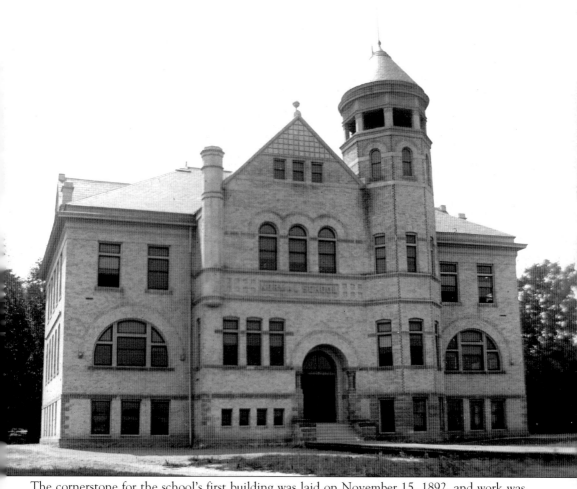

The cornerstone for the school's first building was laid on November 15, 1892, and work was completed soon after. Pictured here, the main Normal School Administration Building was functional, beautiful, and served as the life center of the school for more than three decades. It was also a source of great pride for members of the Mount Pleasant community.

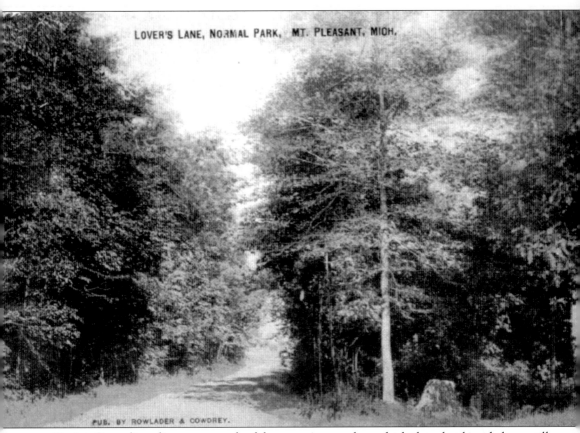

During Central's earliest years, much of the ten-acre parcel on which the school resided was still in its native state, covered with hardwood trees. This postcard depicts "Lover's Lane," a romantic trail through the school's stand of trees. Fred Thurston wrote on the reverse of the card that he "went to a dance Saturday and met a lot of girls, so probably would take a walk there soon."

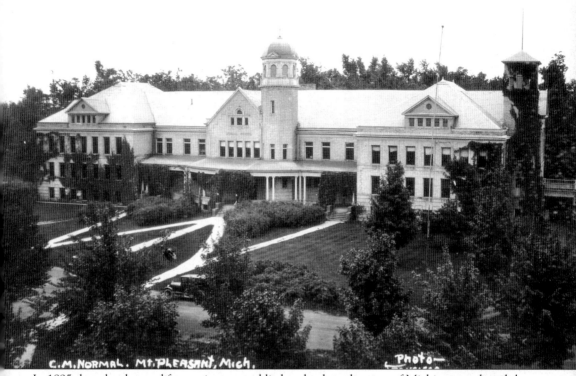

In 1895 the school passed from private to public hands when the state of Michigan purchased the "Mount Pleasant Normal and Business Institute" and changed its name to the Central Michigan Normal School. In 1899, a west wing was added at the cost of $43,000, and an east wing was added in 1902, changing the appearance of the structure and accommodating the need for more space.

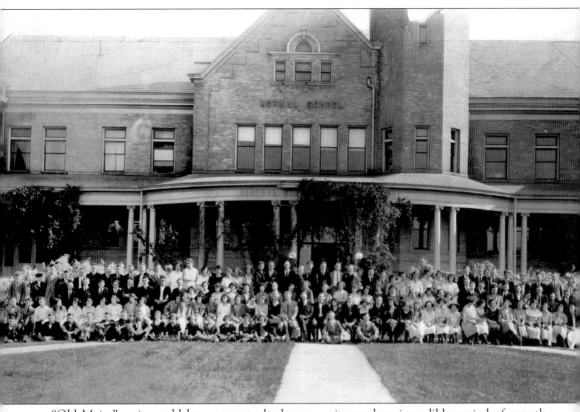

"Old Main," as it would later come to be known, witnessed an incredible period of growth during its tenure and hosted countless guests to Mount Pleasant. Shown here are the participants in the state high school music contest of 1922, enjoying their visit to campus.

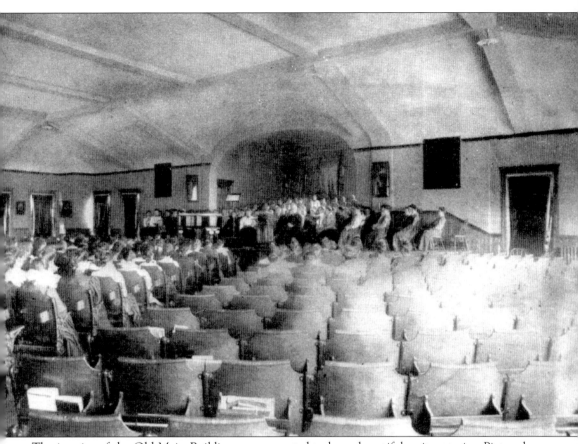
The interior of the Old Main Building was purported to be as beautiful as its exterior. Pictured here are a group of musicians performing in "Chapel Hall" which was located within the building.

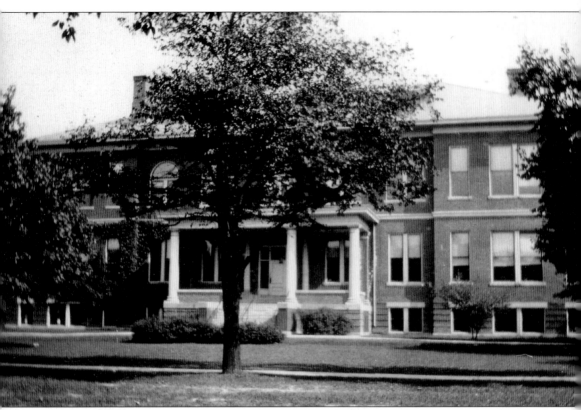

The second major construction undertaken by Central Normal was a Training School, erected in 1902, where prospective teachers gained experience working directly with local students. In the early 20th century, teachers were in great demand and state funds worked to keep tuition to a minimum. The "Rural School Course" of study at Central, for instance, was offered for free and was open to anyone who had graduated the eighth grade. Other teaching-related courses of study charged a nominal $3 tuition fee per term. By comparison, in 2003 each undergraduate credit at Central Michigan University cost in excess of $130 plus fees.

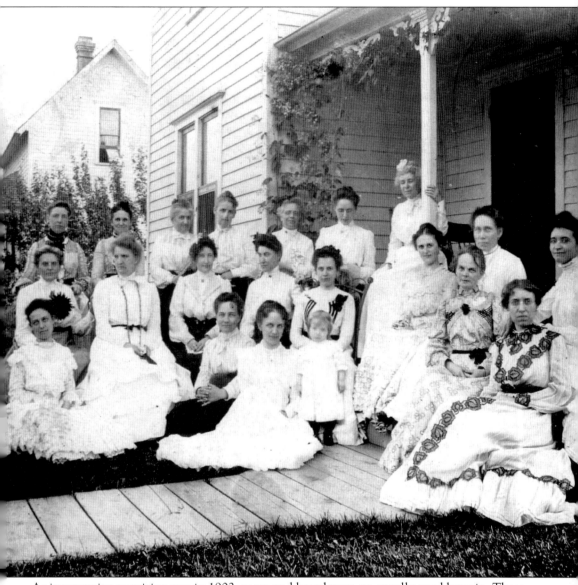

As inexpensive as tuition was in 1902, room and board were an equally good bargain. These ladies were residents of the Ladies' Boarding School House and paid about $2 per month for the privilege. Students also had the option of securing private housing, although this was usually the more expensive choice.

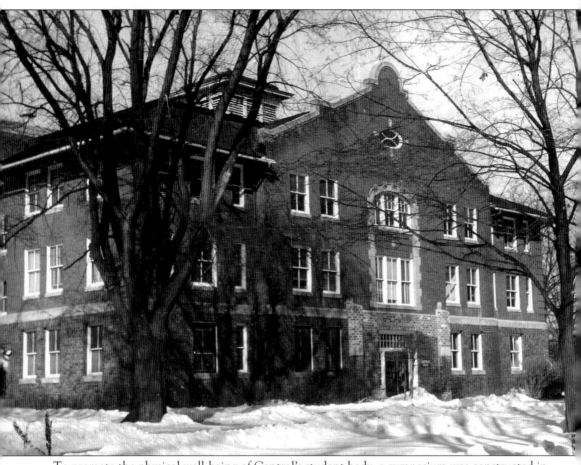

To promote the physical well-being of Central's student body, a gymnasium was constructed in 1909 at a cost of $45,000. The Physical Training Building stood in the area between present-day Ronan and Grawn Halls.

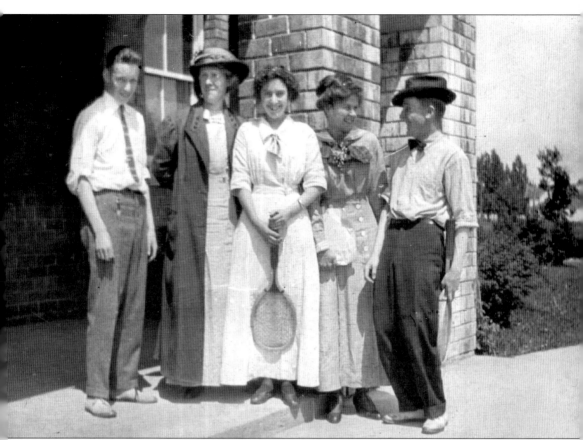

Tennis, anyone? Pictured here, Bertha Ronan (wearing hat), Louise Hale (holding racket), and "Titus" (far right) appear to be looking for a game outside the old gymnasium. Bertha Ronan served as a professor in Central's Physical Education Department from 1903 to 1923 and has since given her name to two different buildings on the campus.

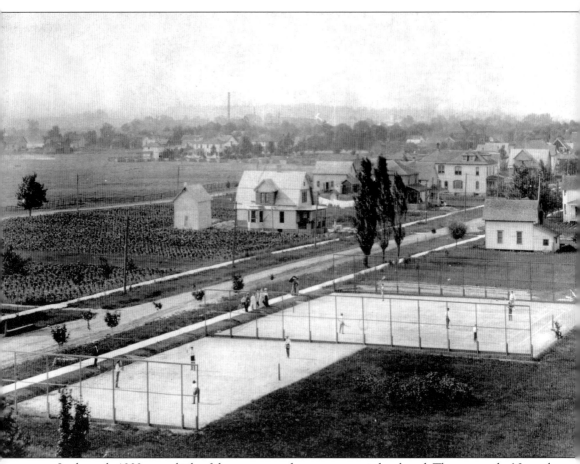

In the early 1900s, very little of the area around campus was yet developed. These were the Normal School tennis courts on the fringe of campus. Downtown is visible in the distance, and large farms can be seen immediately to the west. All of this land is now covered with buildings and houses.

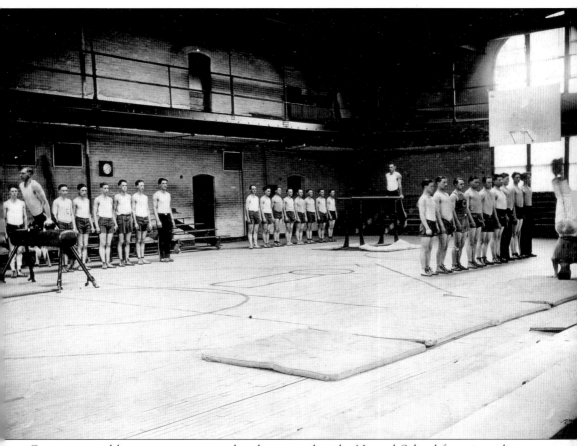

Competitive athletics were encouraged and supported at the Normal School from its earliest years and served as a great source of pride to students and the Mount Pleasant community. Shown here is the men's gymnastics team inside the old gymnasium.

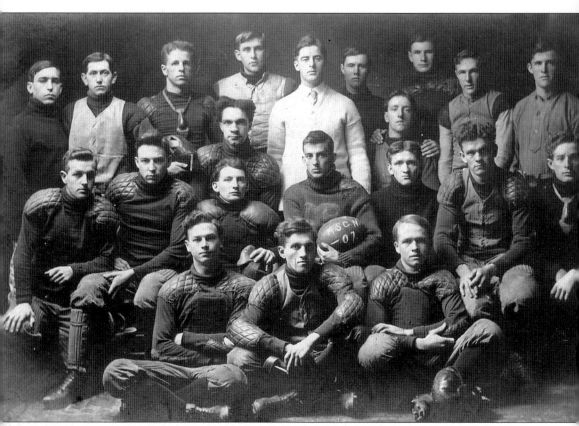
These are the members of the 1907 Central Normal School football team, captured for posterity.

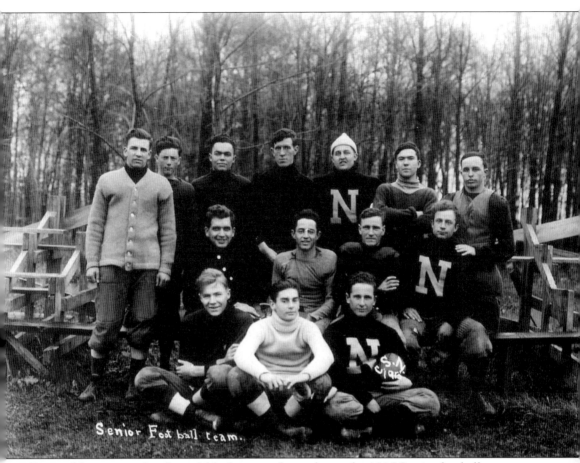
Pictured here is another formidable force on the gridiron: the 1916 Senior football team.

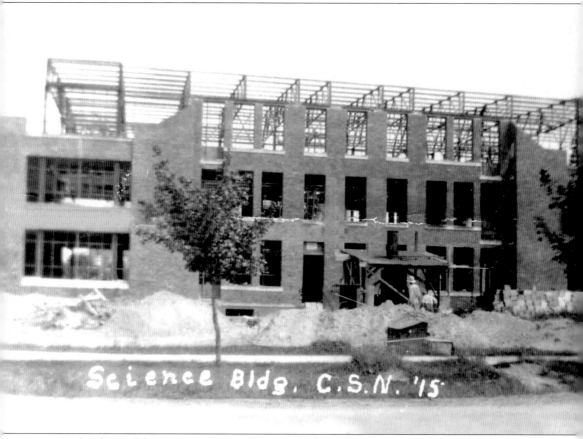

As the demand for access to opportunities in higher education increased, so did the need for more classroom space and expanded programs. To meet this need, Central added the Science and Agriculture Building in 1915 at a cost of $100,000.

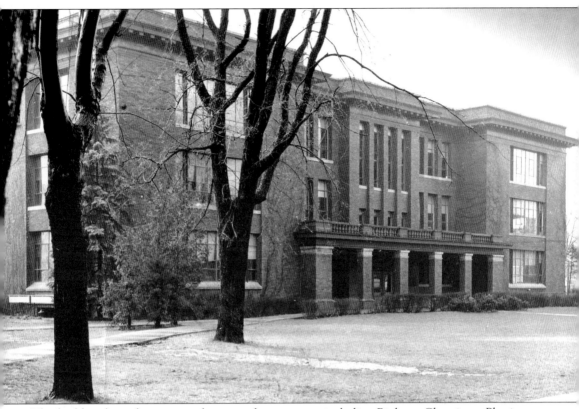

The building hosted a variety of campus departments, including Biology, Chemistry, Physics, Mathematics, and Psychology, among others. Not long after its opening, it was renamed Grawn Hall, a name which it bears to this day. C.T. Grawn served as principal of Central Normal School from 1900 to 1909, as then as the college's first president from 1909 to 1918.

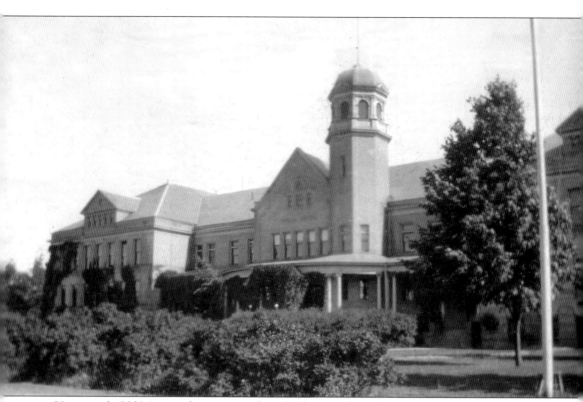

Here stands Old Main in the summer of 1925. This is perhaps the last known photograph taken of the building. Disaster loomed on the horizon.

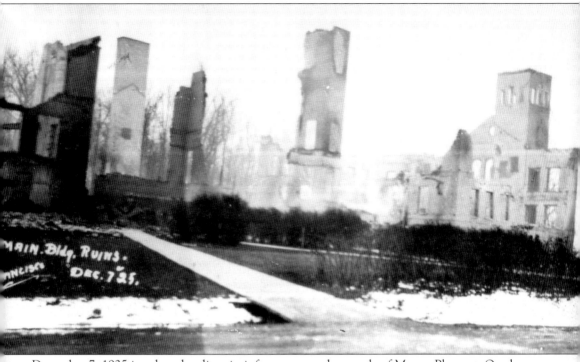

December 7, 1925 is a date that lives in infamy among the people of Mount Pleasant. On that morning, after 32 years as the centerpiece of Central Normal School, the Old Main Building burned to the ground. The origin of the fire remains unknown to this day. Despite the loss, the school continued to operate without interruption after the winter break.

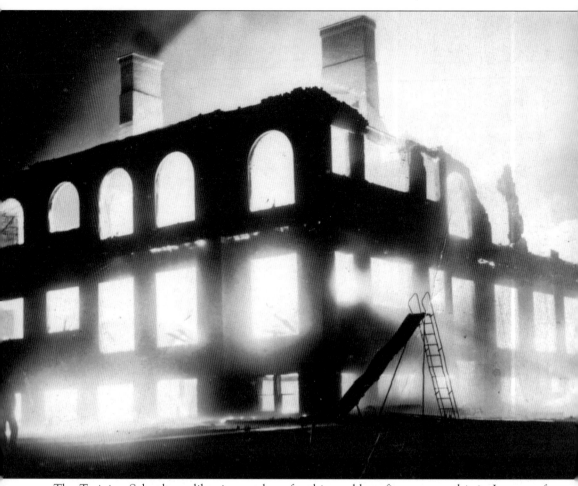

The Training School was likewise not long for this world, as fire consumed it in January of 1933. It had been home to a kindergarten, eight classroom grades, and an extensive library. The only thing left after it burned was the slide.

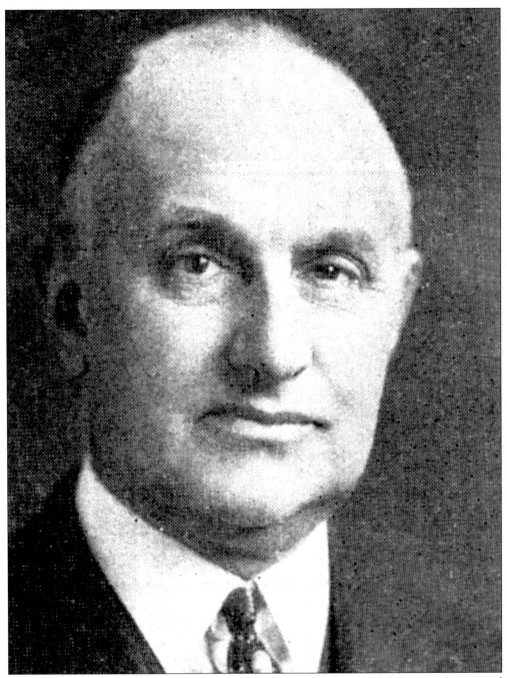

The people of Mount Pleasant and Central Michigan are known for their resilience and determination. Undeterred by the tragedies of 1925 and 1933, the administration of Eugene C. Warriner, pictured here, oversaw the rapid replacement of the Administrative Building and the Training School. Warriner was one of Central's most beloved figures and served the college as president from 1918 to 1939. During his tenure, in 1927, the Michigan legislature officially changed the school's name from "Central Michigan Normal School" to "Central State Teachers College."

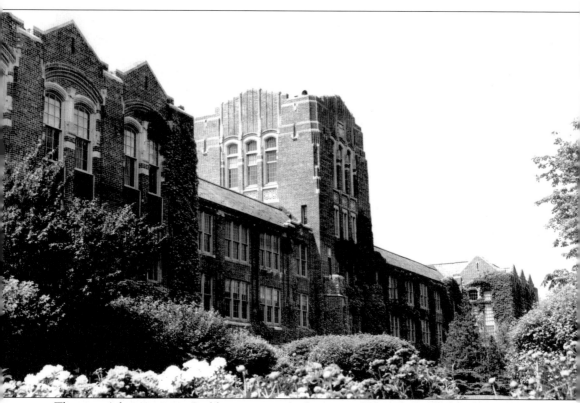

The new Administration Building, soon to be known as Warriner Hall, was dedicated with much fanfare on Sunday, 17 June 1928. Class reunions, music from the college's glee club and string quartet, and countless speeches marked the event. The Physical Education department performed a play entitled *The Builders* to depict the story of the school. Some weeks prior to the dedication, U.S. Senator from Michigan Woodbridge N. Ferris had visited campus to deliver the main address for the laying of the building's cornerstone.

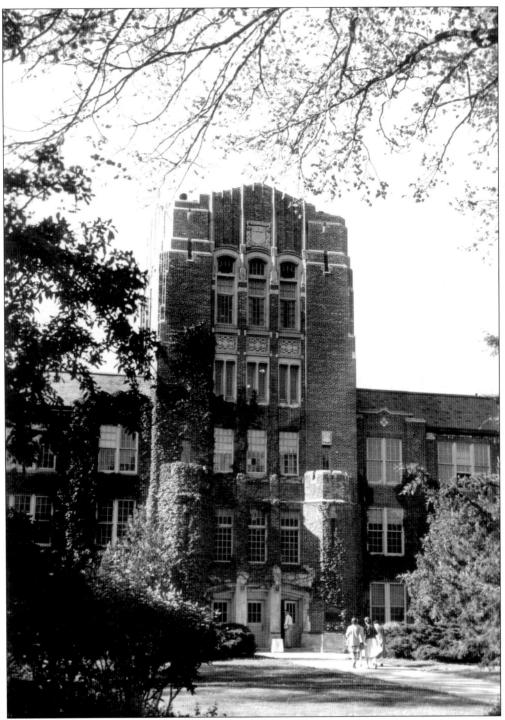

A program distributed for the dedication ceremonies explained the significance of Warriner's gothic tower, calling it "a concrete expression of the history of Western civilization." Today Warriner's tower stands as a symbol of the university and a reminder of a time when aesthetic beauty was of equal importance as utility in the design of public buildings.

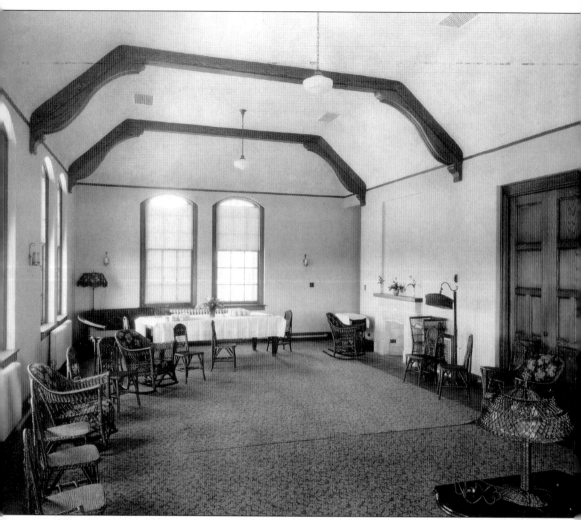

Warriner assumed many of the functions formerly carried out in the Old Main. In addition to serving as the administrative hub of campus, the building housed an auditorium, the school's main library, a full service cafeteria, a women's commons area (pictured here), music instruction rooms, and several academic departments.

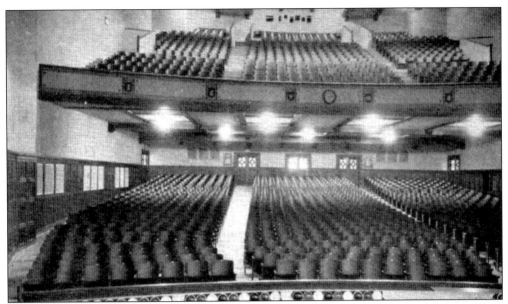

The auditorium in Warriner, with a seating capacity of over 1,500 people, was much larger than Chapel Hall had been in the Old Main. According to one account written in 1928, "it is possible to bring to Mt. Pleasant any orchestra or theatrical production produced in this country with little, if any, 'cutting down' of the scenic effects." The same observer noted that the auditorium's simple decor was "suggestive of the Elizabethan interiors of Shakespeare's day."

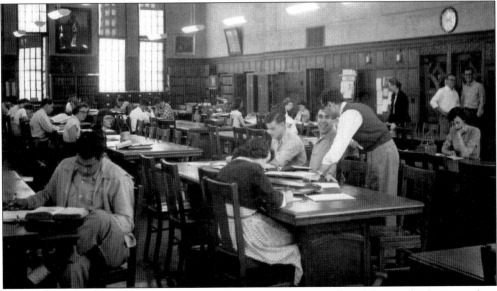

Central's library was located in the east wing of Warriner Hall and featured a large reading room with high ceilings and large windows. Shelving which circled the room provided space enough for 10,000 volumes. Decorative elements included a sculptured plaster ceiling, oak wainscoting, and several chandeliers for additional lighting. Subsequent increases in holdings and student population would render the Warriner Library inadequate, but at the time of its construction it was the academic and social center of the college and remained as the main campus library for three decades.

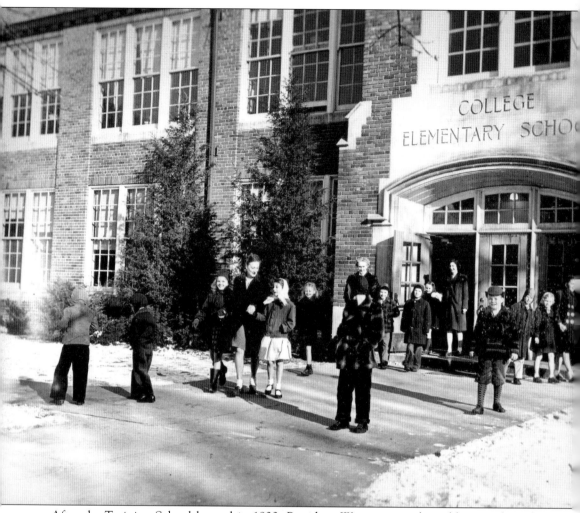

After the Training School burned in 1933, President Warriner acted quickly to replace the facility. The College Elementary School opened in 1934 as a facility dedicated to providing Central State's students with opportunities for practice teaching. State requirements for becoming a teacher had changed greatly since the college's early days, and by the 1940s high school graduation and two years of college were necessary to teach in rural schools. Four years of college was the standard to qualify for city teaching. The College Elementary School Building was eventually expanded and converted into college classrooms. As the departments occupying the building changed over time, so did its name, first to North Hall and later to its present appellation, Smith Hall.

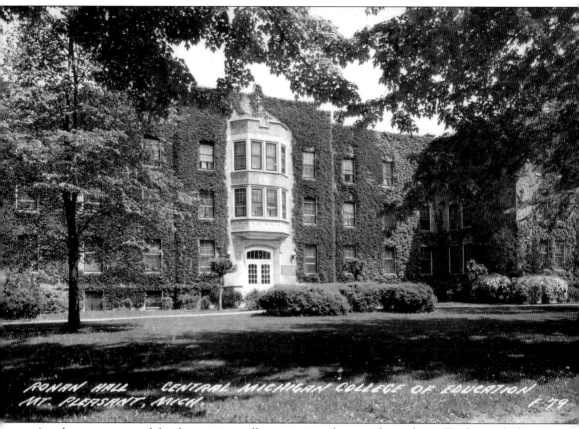

Another pressing need for the growing college was more housing for students. To that end, the Bertha Ronan Residence Hall was opened as the first student residence facility on campus in 1924. It was originally intended to house women exclusively but over time served as a men's dormitory as circumstances dictated. A beautiful, ivy-covered brick structure, Ronan Residence Hall was demolished in 1970 and is now the site of a parking lot. The name "Ronan Hall" now graces a much less attractive building housing the Teacher Education department elsewhere on campus.

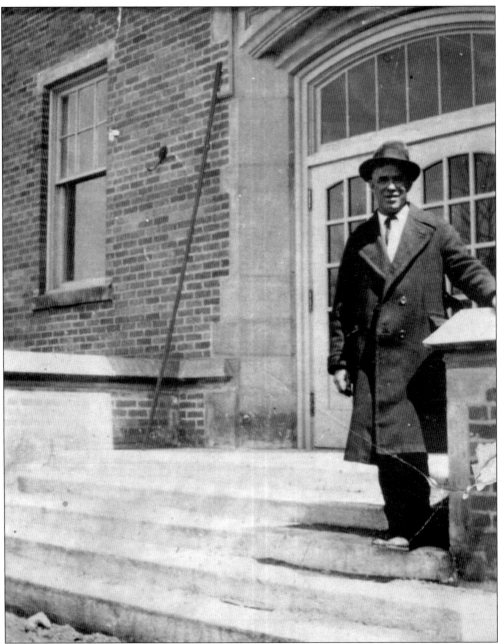

Pictured here on the steps of the original Ronan Hall is construction foreman Bill Smith. Having poured the footings for the building in winter, the frozen concrete thawed by spring and the structure began to settle, causing some walls to crumble. Foreman Smith pulled his crew off the job, fearing that the entire building would collapse. When instructed by the engineer to stay on, Bill Smith reportedly remarked "if you can write, write my check." The structural problem was eventually resolved by extending four concrete columns through the interior of the building.

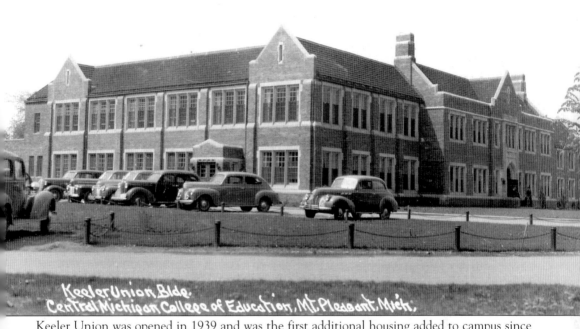

Keeler Union was opened in 1939 and was the first additional housing added to campus since 1924. It served both as the Student Union and as the first men's dormitory at Central. Its namesake, Fred L. Keeler, was head of the college's Science department from 1895 to 1908 and was a popular figure in the Mount Pleasant community.

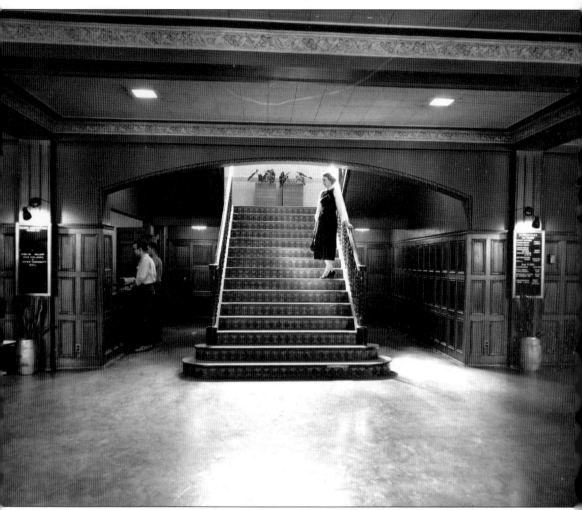

The Student Union section of Keeler featured a magnificent grand staircase leading up from its well-appointed main lounge. Included on the first floor were the lounge (complete with fireplace), a game room, a cafeteria, and a formal dining hall. Elements of the original construction are visible today, although renovations have obliterated the overall appearance of the stately lounge area. In addition to its appearance, the building's name and function were changed in the 1960s, when Keeler became known as Powers Hall and served as home to the Music department.

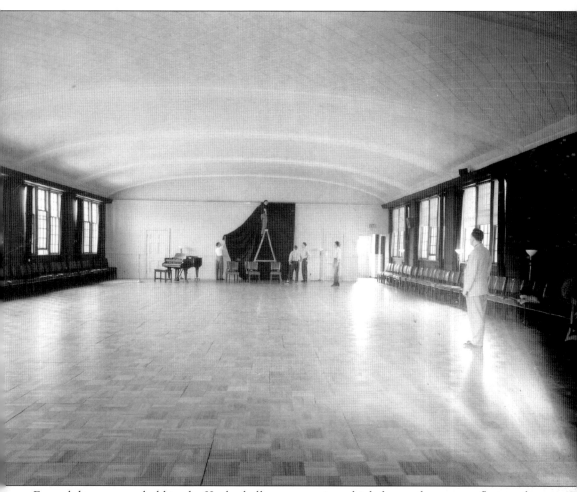
Formal dances were held in the Keeler ballroom upstairs, which featured a parquet floor and a baby grand piano. Other areas of the second floor included a billiards room and a women's lounge. The ballroom is still intact today, but nowadays visitors caught dancing are usually met with curious stares.

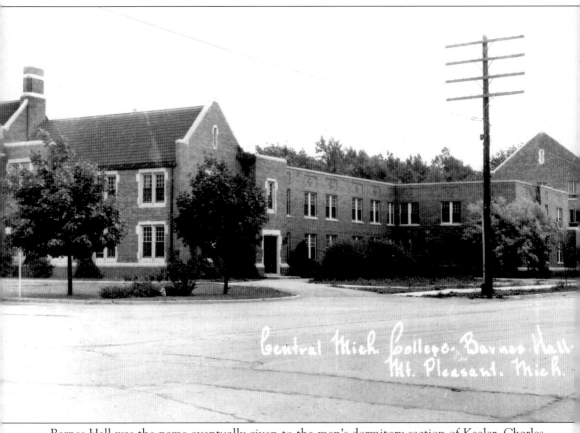

Barnes Hall was the name eventually given to the men's dormitory section of Keeler. Charles Barnes was the first dean of men at Central. The dormitory initially met with mixed success and operated for some time at less than full capacity, as the school found it difficult to attract men away from more "festive" off-campus private housing.

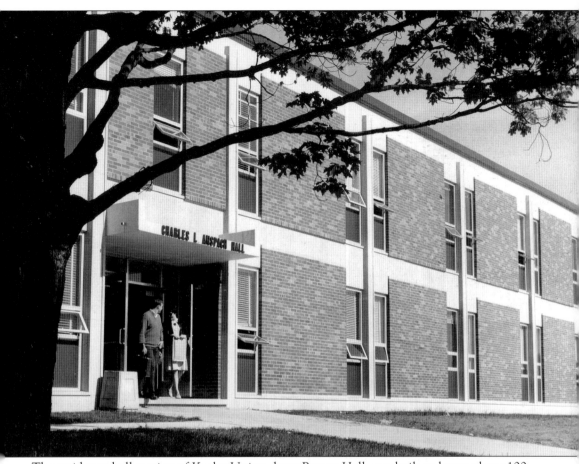

The residence hall section of Keeler Union, later Barnes Hall, was built to house about 100 men, but this capacity later proved inadequate to meet demand. The dormitory was expanded in 1951 and again in 1957. The 1957 expansion, while functional, was among the earliest of a slew of extraordinarily ugly brick structures designed by Grand Rapids architect Roger Allen and Associates in the 1950s and 1960s for the Central campus. Among these are some of the university's most important current buildings: Pearce, Anspach (pictured here), Brooks, and several residence halls.

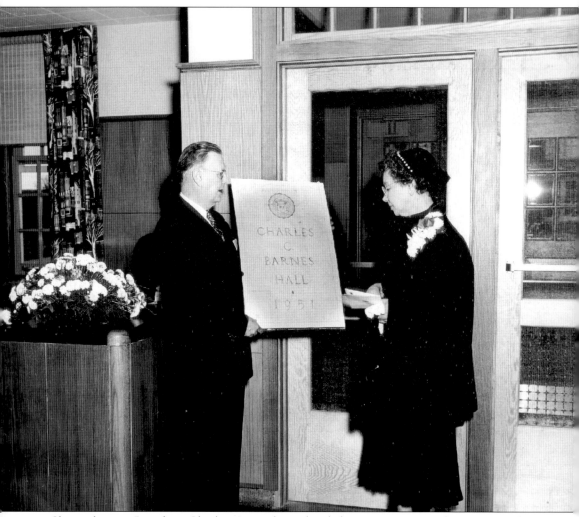

Shown here is President Charles Anspach at the dedication ceremony for Barnes Hall on October 25, 1952. Anspach began his 20-year term as Central's president in 1939 and presided over a period of dramatic expansion and change. In a 1943 "Post War Public Works Program" report issued by the college, Anspach outlined his expansive vision, citing the need for a new gymnasium, a new elementary practice school, a library, a science building, an arts and crafts building, and more classroom space and land. Between 1939 and 1956, this vision had materialized in the construction of several new buildings and more than a doubling of student enrollment, which stood at 5,913 students in 1956.

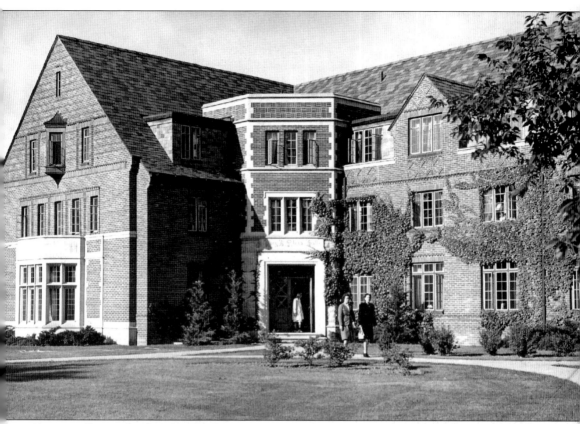

Sloan Hall was the first building on campus carried out completely under the watch of President Anspach. Built in 1941 in the tradition of classically beautiful college architecture, Sloan had a capacity of 148 women but often housed many more, especially during wartime when Ronan Hall was occupied by military trainees. The dormitory was named for Lucy Sloan, an early head of the English department and inaugural "Preceptress" of Central Normal School. Also in 1941, Central State Teachers College again received a name change, becoming "Central Michigan College of Education."

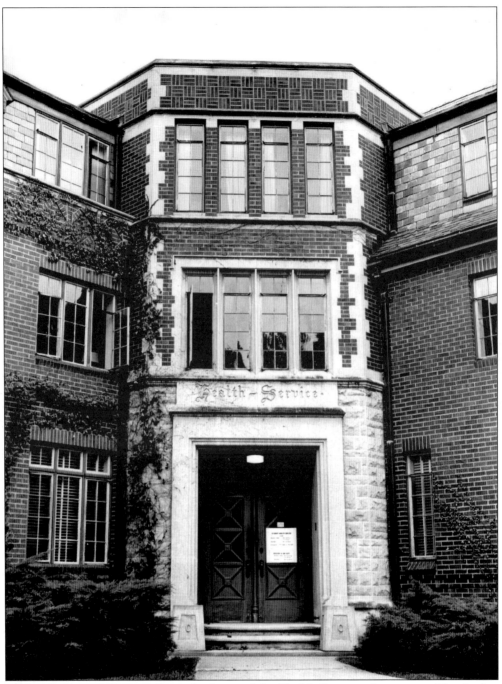

The south wing of Sloan Hall was the home of the Health Services department. This facility was equipped with medical staff and a pharmacy, and provided quality health care to Central students at low or no cost. It now houses the Psychology department.

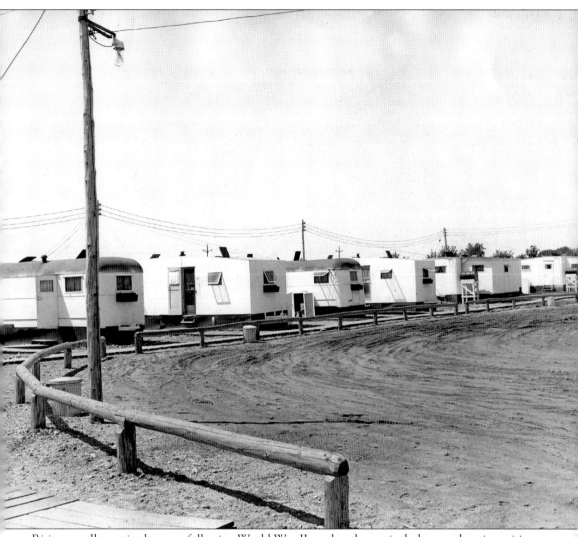

Rising enrollment in the years following World War II produced a particularly acute housing crisis on campus and led to the construction of two new housing complexes in the late 1940s. One of these was a collection of barracks halls known as the "Sheep Sheds." An alternate name was "Vetville," as the dwellings hosted large numbers of military veterans entering school after the war.

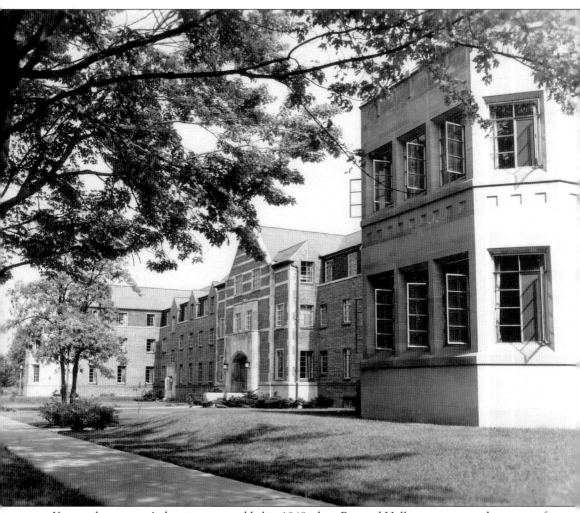

Yet another women's dormitory was added in 1948 when Barnard Hall was constructed at a cost of $1.4 million. It was a popular place of residence among students and once hosted former First Lady Eleanor Roosevelt on her visit to campus. Anna Barnard, the building's namesake, was head of the Foreign Language department at Central from 1899–1944. Barnard Hall was closed in 1993 and later demolished in 1996, thereby freeing up funds for the construction of less attractive housing.

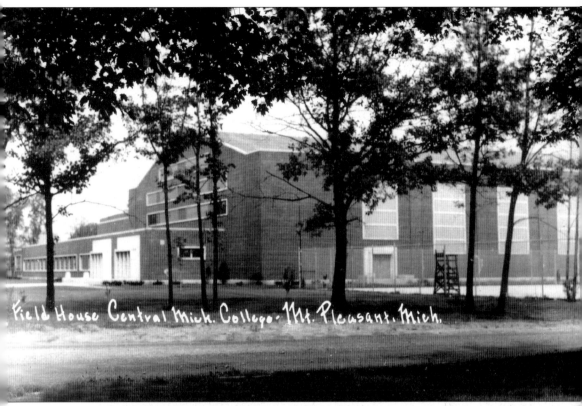

Finch Fieldhouse, as the building pictured here would later become known, was a cavernous structure opened in 1951 to serve as the primary athletic facility on campus. It had a basketball court, an indoor track, and a swimming pool, as well as a seating capacity of 4,700. Finch has hosted scores of high school and collegiate athletic events over its lifetime, and even served for a recent brief period as the school's library. The Fieldhouse was named for Ronald Finch, a longtime coach at Central and head of the Physical Education department.

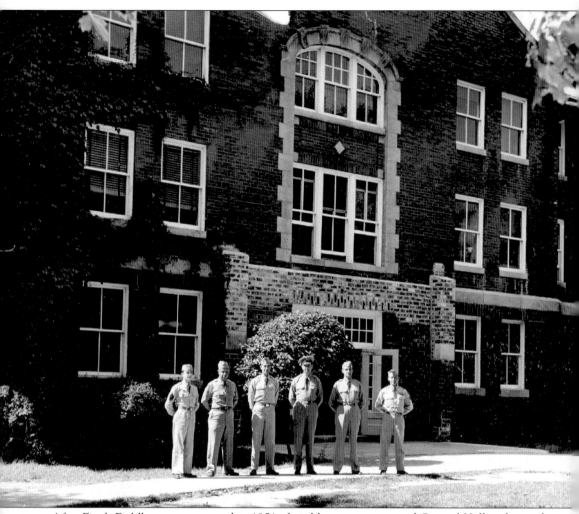

After Finch Fieldhouse was opened in 1951, the old gym was renamed Central Hall and served as the headquarters for the ROTC program at Central. Later, in 1970, Central Hall gained notoriety when student protesters occupied it for five days to demonstrate their opposition to United States military action in Southeast Asia. After standing for 65 years as a fixture on campus, the old gymnasium was finally demolished in 1974.

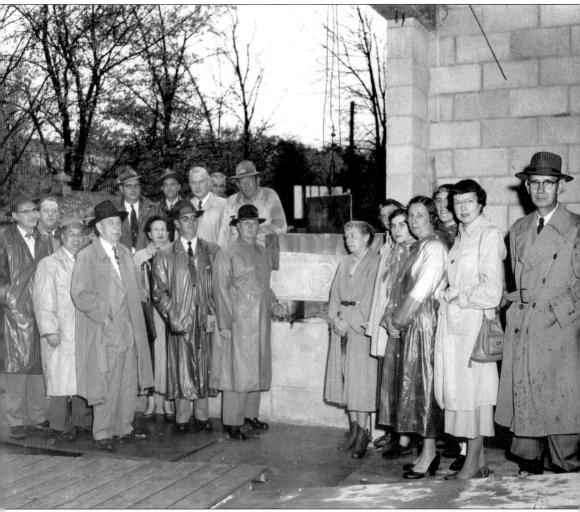

By the 1950s, the library in Warriner Hall proved insufficient to handle the dramatic increase in holdings and in students using the facility. This picture, taken in October 1954, shows the laying of the cornerstone for a new library, which later became the second Ronan Hall. The new library was also home to the Clarke Historical Library, a special collections library with a large number of rare books founded after a donation of materials from Dr. Norman Clarke. The main Central Michigan University collection and the Clarke Historical Library have since taken up residence in one of the school's more architecturally creative and technologically advanced modern buildings, the Charles V. Park Library.

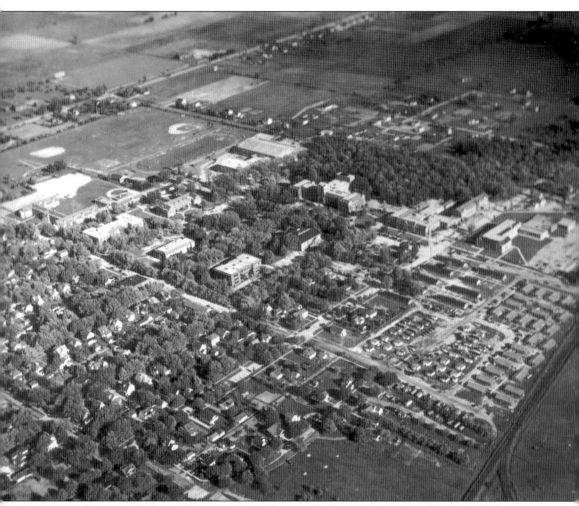

Like the city of Mount Pleasant, Central's growth during the first half of the 20th century stands as a tribute to a community of men and women dedicated to progress. By 1954, the one-building school on a ten-acre wooded lot had expanded into an institution the scope of which even its forward-thinking founders probably would not have thought possible. This aerial photo depicts graphically just how much the school had grown. In 1959, the college was to receive its final name change when it was officially recognized as Central Michigan University.